# PHOTOGRAPHERS
## AND THEIR
# STUDIOS

### CREATING AN EFFICIENT AND PROFITABLE WORKSPACE

## Helen T. Boursier

AMHERST MEDIA, INC. ■ BUFFALO, NY

# Dedication

A special thank you to all twenty-two studios for the beautiful photographs of their wonderful studios. This book would have been an impossible endeavor without their enthusiastic support. Thank you!

—*Helen T. Boursier*

Copyright © 2001 by Helen T. Boursier.

Contributing photographers: Patricia Beltrami, Chris Beltrami, Helen Boursier, Mike Boursier, Barbara Box, Doug Box, David Clapp, Susan Clapp, Gary Fong, Marci Fong, Alvin Gee, Jay Goldsmith, Nancy Green, Elizabeth Homan, Hugh Jacob, Ib Larsen, Ed Lilley, Sue Lilley, Deborah Madearis, Roy Madearis, Andy Marcus, Alfonse Micciche, Thomas Micciche, Dwight Okumoto, Kay Okumoto, Kitty Reedorf, Ralph Romaguera, Julia Russell, Joseph Simone, Louise Simone, Ron Simons, Magaritha Straw, Peter Straw, Sandra Thibeault, Gary Thibeault, and David Ziser.

Published by:
Amherst Media, Inc.
P.O. Box 586
Buffalo, N.Y. 14226
Fax: 716-874-4508
www.AmherstMedia.com

Publisher: Craig Alesse
Senior Editor/Production Manager: Michelle Perkins
Assistant Editor: Barbara A. Lynch-Johnt

ISBN: 1-58428-047-6
Library of Congress Card Catalog Number: 00-135901

Printed in Korea.
10 9 8 7 6 5 4 3 2 1

TR550
.B68
2001x

Notice of Disclaimer: The information contained in this book is based on the author's experience and opinions. The author and publisher will not be held liable for the use or misuse of the information in this book.

# Table of Contents

# Introduction

This book, my seventeenth, is the completion of a process of literally coming home. Together with my husband and business partner, Michael, we started our home-based photography business in 1983. As business gradually increased, we felt the need for a "real" studio. When our son entered kindergarten, we relocated Boursier Photography to the first of two commercial locations in the heart of our small town on Cape Cod, Massachusetts.

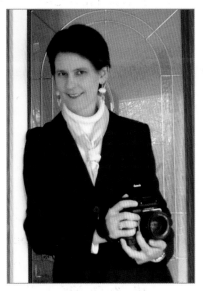

*ABOVE: The author at the door to her studio.*

The commercial locations gave a more professional look for the business and more privacy for our family. We always knew we would one day return to a home-based studio. When Jason graduated from high school and prepared to go off to college, we realized it was time to bring our business back home.

In the process of planning and designing and building and decorating our new home studio, we poured through volumes of "how-to" books. The one book that would have been the most helpful is the one book that did not exist. It is the book

you now hold in your hands. *Photographers and Their Studios* is not a how-to book per se. It is a peek inside the working studios of successful professional wedding, portrait and commercial photographers from across the U.S. and around the world. The book includes a cross section of studio sizes, styles and locations. You will read about decadent dream studios designed from the ground up, as well as scaled down studios built to make the best of a small existing space. One photographer uses a converted garage, while another has a living room in his home that doubles as camera room for the business. Many of the contributing studios are single-owner, but some are multi-owner, multigenerational and/or multi-location businesses.

Whether you are ready to open your first photography studio, give your current studio a face lift, or make a dramatic move up (or back) from your current studio, *Photographers and Their Studios* will give you ideas galore. The photographs show you what photographers did to create their one of a kind look and the copy tells you why they made the design and decor choices. As you pick and choose the bits and pieces that will work for you, you will truly design a photography studio of your own.

Enjoy!

*Helen T. Boursier*

# Seaside
# Resorts

# Cape Cod Artists

When our son entered kindergarten, we moved our fledgling mom-and-pop studio from our rinky-dink home studio location to a prestigious office condo complex in the center of our small town on Cape Cod, Massachusetts. We wanted credibility for our business and privacy for our family. Thirteen years later when Jason graduated from high school and prepared to move off to college, we relocated our thriving business back to a residential neighborhood.

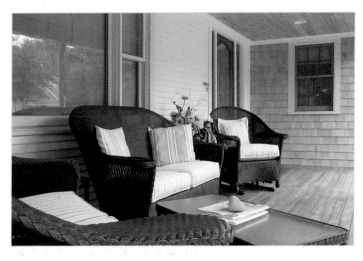

ABOVE: *Top quality wicker furniture on the farmer's porch creates a friendly first impression.*

We were a little nervous about moving back to a home-based location, fearing we might loose some of that hard-earned credibility. However, during the transition from the commercial location to our home, we uncovered two key points which made our worries groundless. Basically, our

clients considered us to be artists, and that label came with certain allowances for any idiosyncrasies associated with being artists. Also, our Cape Cod location provided an additional level of tolerance. All the towns are small in this resort community located an hour and a half south of Boston, but the population (and commerce) fluctuates dramatically with the influx of summer tourists. Consequently, many professionals (contractors, veterinarians, accountants, dentists, etc.) run home-based businesses. We took these allowances, and applied the lessons learned from our thirteen-year hiatus at a "professional" location to make a successful transition back to the comforts of home.

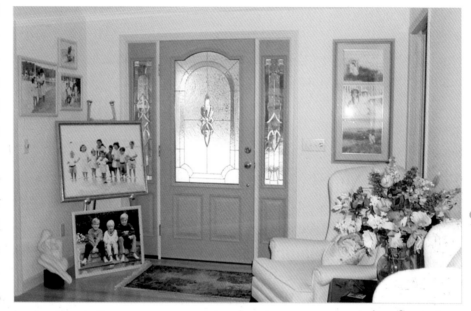

The office condo commercial facility helped us to build our business. It gave us credibility of having a "real" studio during the years we were growing our full-service wedding and portrait business. However, as we gradually redefined and reshaped our business, we also changed what we actually needed for a studio facility. Instead of offering a myriad of indoor and outdoor photography services over a twelve-month period, we offered hand colored black and white portraits of families and children photographed exclusively on location between May 1st and September 30th. We used the fall to complete the hand coloring and framing, and we completely closed the studio during the winter months while we pursued the writing phase of our business cycle. Instead of a high visibility location for a volume business, we needed a comfortable place to work with a select group of clients seeking one-of-a-kind hand colored art pieces. We didn't need a fancy studio to

*ABOVE: The front reception room serves as an extra "over-flow" room when one client is early and another is running behind. It also serves to showcase a variety of the types of products we offer and includes a frame wall and "brag" wall. We never liked the solid front door at our office condo location, so we chose a translucent glass with some clear areas so clients can peek inside and see that they are, in fact, at the right place.*

9

impress clients because our work was doing that for us. We also didn't need the camera room since virtually all of my photography was, and is, done on location.

What we needed was simplicity. Boursier Photography needed a viewing room to show clients portrait choices after the photography sessions and a place to hand color and frame the black and white portraits.

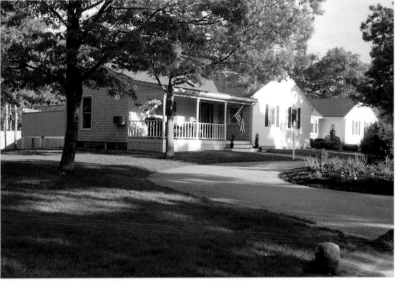

Before we began the big move, we went to Town Hall to check the regulations for operating a home business. Then we designed a "wing" off of our ranch-styled residence to comply with those rules. We added a 450 square foot reception area, which includes a small waiting room, a larger sales room and a client bathroom. An open, beamed cathedral ceiling makes the space feel larger. We converted the adjacent bedroom, for-

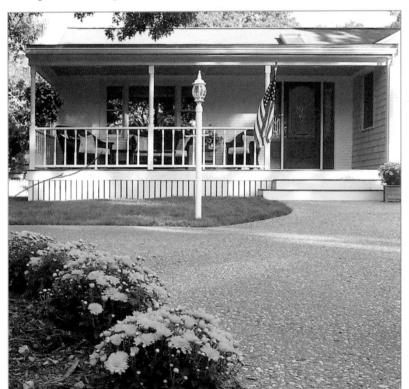

*ABOVE: A "wing" addition to the existing ranch home blends with the original design. Mike makes sure the lawn is meticulously cared for during the summer months when our seasonal business is in full swing. Neighbors stop to comment that it is the best lawn on the street.*

*LEFT: The circular drive brings clients to the separate studio entrance. To make the driveway even more distinct from the normal New England choice of blacktop, we used exposed aggregate on concrete. The circular drive and studio entrance are at the opposite end of the house from our personal driveway. The flag by the front door tells clients we are open and expecting them.*

merly our son's, to an office for my winter writing. Mike easily converted the basement below the addition to accommodate my handcoloring and his framing and shipping.

Our original home studio afforded no separation between personal and business because it was located in our first home, a split-level ranch. When clients walked in our front door, it was obvious they were entering our residence. We made personal privacy a high priority for the new home studio location, located at the end of a two-block-long "no outlet" residential street. We had a circular drive built in front of the new wing, bringing clients to the separate studio entrance at the beginning of the property. To help clients find us as easily as possible, we include detailed directions and a photograph of the entrance in the 24-page planning booklet we mail to all clients.

ABOVE: *Sunflower accent pieces match the front porch decor and bring a personal touch. Sunflowers are the state flower of Helen's childhood home—Kansas.*

There is no sign. Although town regulations allow a two-foot-square unlit sign for residential businesses, we want our clients to come to the studio by invitation only. We do not want drive-by drop-ins. By having clients make prior arrangements to come to the studio, it guarantees we are available when they do arrive. We do not get unexpected company and they are ensured our undivided attention. Since we accept only 125 sessions per season, we actually get less business traffic on any given day than most of our neighbors get for personal visits!

The front porch was an important design element for the studio addition. We wanted it to serve as a friendly welcome to

12

clients and to set the mood for the quality and style of the portraiture they were about to view inside. We had no idea how much our clients would love that porch! The men comment on the beautiful mahogany flooring and the women comment on the top quality wicker furniture. Everyone loves the gorgeous lead glass and wood front door. On a practical note, the 8'x26' porch makes it easy to get in and out of the studio on rainy days and serves as a back-up location for family portraits on those same rainy days. The porch also turned out to be a great place for children to wait for their parents. Where parents would never have dared to leave children unattended in the

*ABOVE: The oversized window in the sales room faces the north side of the studio. We had it positioned to allow ample room to pose small groups using nothing but a reflector for fill light. The curtain can be removed easily, and the furniture slides out of sight to the right. Helen uses the blank wall to the left of the windows to project slide proofs.*

busy parking lot at our former office condo location, they feel perfectly safe letting them read books or draw pictures while sitting on our front porch swing. When children get bored with the toys we provide inside, they simply shift gears and bring books and drawing paper outside. It is great for the kids, great for the parents and easy for me.

For the decor, we started completely fresh, literally from the ground up. We got rid of everything from the old studio, including all the blue furniture, camera room props, backgrounds, portrait samples and frames. Then we blended the tastes of our clients with our own. Two years ago we adopted the policy of personally delivering completed portraits to as many of our clients' homes as physically possible. All that driving around really came in handy when it was time to choose the decor for the addition. We easily applied many of their wonderful decorating ideas. For example, one client used dozens of designer pillows to accent all her furniture and another had a beau-

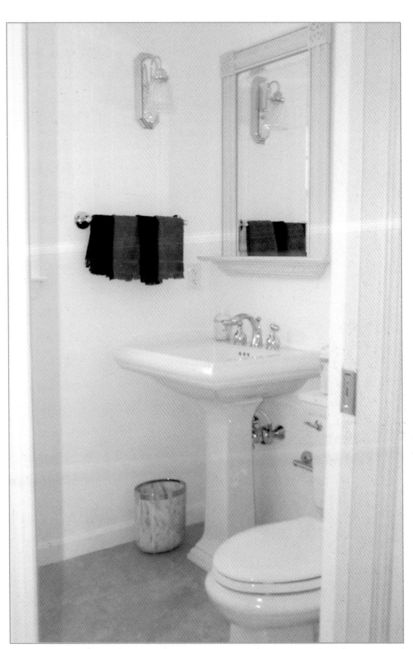

*ABOVE: The common bathroom at our office/condo location was an embarrassing sore spot with us. It just wasn't nice! Even though this is "just" a bathroom, we made it as nice as the rest of the studio by choosing top quality fixtures. We keep it meticulously clean, and change the hand towels after each client, so it always looks fresh.*

tiful quilt tops made into shades for her large picture windows. I also noticed that the majority of my clients had hardwood floors in their formal rooms and that cream or natural was the most popular color choice for living room walls.

Since like attracts like, we applied my lessons learned from touring these homes. We chose cream for the walls but added my personal signature color of purple as an accent. To give the room my own personal touch, I made a quilt window treatment and fancy one-of-a-kind pillows for the sofas and chairs. I also had the old studio furniture upholstered to match the new color scheme. A local florist designed arrangements for the vases we had purchased in Switzerland while attending a photography workshop. The flowers added a beautiful splash of color and the vases created an excellent conversation piece about our winter travels.

Music is an important element at our home. Mike and I both dislike browsing in a store with poor music, and we will walk out if the store is so quiet that you can hear the proverbial pin drop. Mike wired both studios with speakers and set up a stereo system to enable continuous background music of my

*BELOW: Including your personal touches is the best part of home studio decor. I collected purple upholstery fabric during my travels. I made the quilt window treatment, then upholstered the small pieces of furniture, and hired out for the sofas and wing chairs.*

14

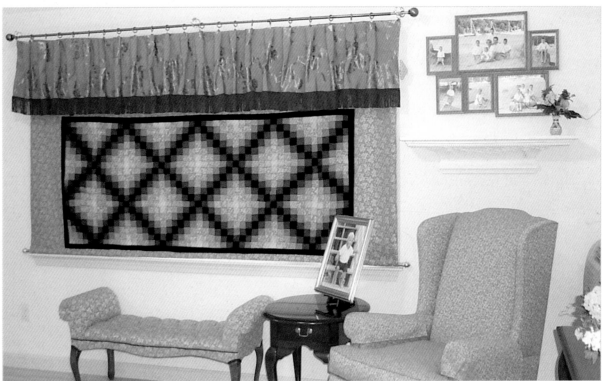

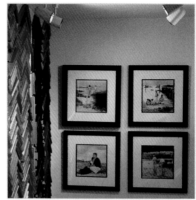

*ABOVE: A small alcove gives us triple mileage. The left wall holds 350 frame corners, the right wall features award plaques and framed book covers. The center wall showcases a popular frame style.*

*LEFT: Details make the difference for upscale decor. Pillows accent all the furniture and custom floral arrangements add a splash of color around the room.*

15

choice. I play what friends call "health food store music"—basically new age classical. It is soft enough to be background music but not quiet enough to make you feel like you are in a funeral parlor.

The only real issue I struggled with in downsizing the studio was the reduced amount of wall space to display sample portraits. I use the walls to showcase distinctly different portrait presentation styles, which we call "concepts." For example, one wall shows two large hand colored black and white portraits from the same session that are matted and framed so they complement each other. Another wall shows a grouping of three large classic black and white portraits on canvas that are framed to the edge. The narrow wall by the front door displays three 11"x11" family portraits matted and framed as one vertical piece. Each wall represents a distinct product and a

unique way to display portraiture, making the entire studio one big opportunity for the classic elementary school activity of "show and tell."

The completed project has the feeling of the "company room" that most of my clients have in their own homes. For those who don't have such a room, they often comment, "I want a room like this when our children are grown." The decor helps clients to feel comfortable, and the professionalism reminds them the purpose of the visit is business.

*ABOVE: Since every wall shows a different way a client can display portraits in their own home, the portraits from each grouping are of one family.*

ED AND SUE LILLEY

# Seaside Tourist Village

Ed and Sue Lilley opened their first photography studio in Alberta, Canada in 1974. Then, in 1979, they decided to return to their New England roots and open a home studio in Harwichport, Massachusetts, a small tourist town on Cape Cod. They bought a house with an attached carriage house, which was situated two blocks from the heart of town on Main Street in a neighborhood that is a combination of commercial and residential buildings.

*BELOW: $5000 double doors on the front of the studio make a lasting impression.*

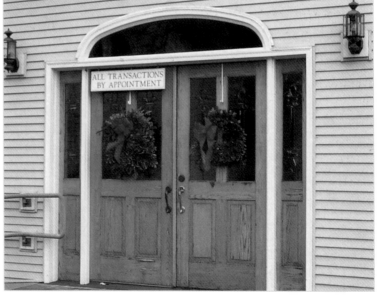

Ed calls the carriage house "just a fancy word for barn." Built in 1888, the interior was "decorated" entirely in wood. The walls had wood paneling and the hardwood floors had permanent oil stains from the cars

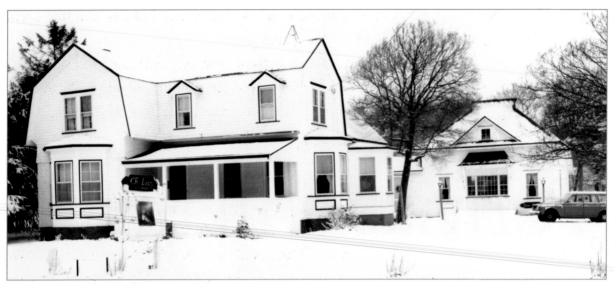

Top: *The home studio in the original carriage house (c. 1980).*
Bottom: *The updated studio design included details from the original carriage house that was built in 1888.*

that had been parked there. Ed said, "It was a raw open room with no heat. We insulated and added heat the first year, and opened for business." Ten years later, they tore down the carriage house and built a studio from scratch.

"We came to realize that you can only push an old building so far, particularly when it comes to energy costs," Ed said, adding, "It was easier to tear it down and start over than to keep making renovations." They built a modern facility with 1700 square feet of customer space and a full basement for worker and production space.

They were careful to maintain some of the architectural elements of the carriage house in the new building to preserve the balance with the existing house and the seaside community neighborhood. The main floor includes a large reception room, framing room, gallery room and the 17'x24' camera room. Their basement has 9' high ceilings and houses a full color lab facility, black and white darkroom, artwork area and shipping and storage rooms.

"We designed the studio to achieve two effects. We wanted a sense of open space and lightness. We also wanted to give clients an expensive first impression," Sue explained. To satisfy both criteria, they made the main reception room large with

lots of windows to allow natural light indoors, and they spent $5,000 on their front doors.

"We wanted a strong first impression, so we spared no expense on the front door. Every customer who walks through those doors comments on how nice they look," Ed said.

Those doors give way to an open-styled studio with 10' high ceilings. The foyer is used as a gallery and they meet with clients in the remaining reception room space. Huge windows and overhead skylights allow in lots of soft, natural light. Wall portrait samples include two 40"x60" portraits on canvas. One is of a family group and the other is from a wedding. "We wanted to impress our clients who own large homes, but we also wanted the studio to be comfortable and a reflection of our personal tastes," explained Sue. "Our business persona is an extension of our outgoing personalities. We want clients to know we are really nice people who want to be their friends."

E.R. Lilley Photography is evenly divided into three separate businesses within the business. They photograph thirteen to fourteen Sweet Adeline competitions (lady barbershop choruses and quartets) during the spring, weddings and outdoor families during the spring and summer and 3,500 underclassmen in three junior highs, three elementary schools and several day care schools during the fall. "What makes the mix work is that each one is seasonal," Ed said, explaining, "Each one has its own primary season, with only a little cross-over to the start of the next segment of our business." Ed is the photographer and color darkroom printer. Sue does print enhancement and wedding album assembly. Her sister, Nancy, is the office manager. During the spring and fall, they also hire two women to work school hours (9 a.m. to 2 p.m.) to open envelopes and count money, then sort and package the completed orders.

ABOVE: *Gallery area inside the front door greets clients.*

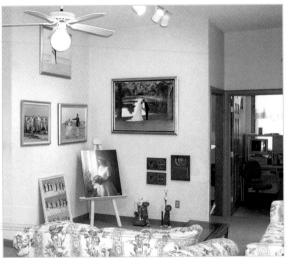

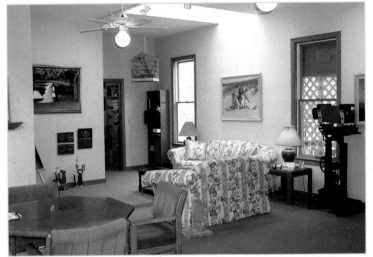

*ABOVE: The open design of the reception area creates a spacious feeling for clients. The six-foot-high windows and overhead skylights enhance the light, friendly feeling by allowing in plenty of natural light.*

The three Lilley sons have, at one time or another during their teenage and young adult years, worked for the studio. Ed advised, "You cannot force your offspring to work in the studio. Either they want to work, or they don't. Also, if they do work, it is a job. As each of our sons has worked for the business, whether they were printing in the darkroom or assisting at a wedding, we expected them to treat it as a job. We expected them to work, and they expected to get paid."

Ed said his best advice for those building studios is to anticipate the future and build for flexibility. "Every space in your studio should have multiple potential uses. Be wary of building to conform to a particular style of photography that you are currently doing. He cited his own camera room as an example of poor long-range planning. He built the grandiose camera room at a time when he was photographing many studio portraits. Just a few years later, Ed was rarely using that expensive part of the addition since he photographed most of his portraits on location. He said, "It is inevitable that your photographic styles will change through the years, but changing a building to suit those changes is expensive."

# Lessons Learned

Plymouth, Massachusetts studio owner Nancy Green has operated her portrait and wedding studio out of four different facilities since she started her business in the living room of her small rental house in 1979. Her current commercial location in the seaside community where the Pilgrims first landed is a culmination of lessons learned—and some learned the hard way.

Starting with the home studio scenario, Nancy loves to tell the story of the Sunday morning when an unexpected client showed up on her doorstep. Nancy had photographed a late wedding on Saturday night and had another wedding lined up for Sunday afternoon. She decided to grab some sunshine and a little peace a quiet before she had to dress for the wedding. "There I was, lathered up with suntan lotion, lying on a chaise lounge in my swimsuit when a client drives up and demands my attention," Nancy said, adding, "I flipped out. That was it. I knew it was

ABOVE: *Sign over front door.*

time to get the studio out of our home." They moved the business to its own "home" studio location, and happily lived elsewhere.

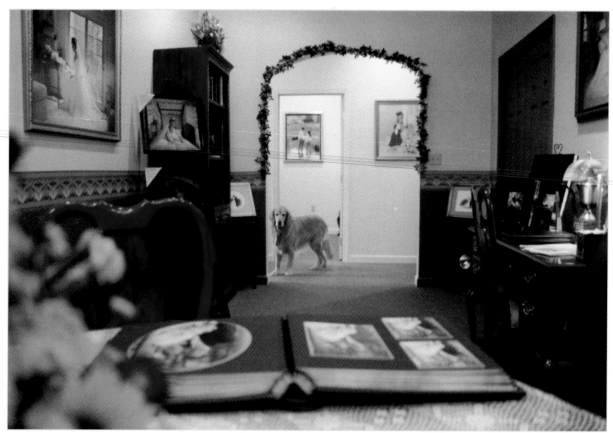

*ABOVE: Wedding sales room with Nancy's dog and studio mascot, Holly, standing in the doorway.*

Then they built what Nancy laughingly calls, "The Monster." They built a 6,000 square foot facility, which included an additional 4,600 square feet of rental office space. Nancy Green Photographers included a full-time sales and office staff of five, two full-time photographers and another part-time photographer for small jobs. "We needed to hire two more full-time photographers so that when my partner and I were not using the camera room, someone was in there taking photographs," she said, but added, "When we didn't have the camera room staffed, we turned a ton of work away. With our overhead, we needed to keep the camera room booked solid."

After four years, the bottom fell out of the economy in New England in the early 1990s. The rental property wasn't renting and the camera room wasn't fully booked.

Looking back on the lessons learned from those years, Nancy said she learned a lot about herself as a person and as a business owner. "It is the control thing. I want to know that I have control over every situation. I want to know that I am not going to be left in a lurch when a photographer doesn't show up or doesn't do the job right. I learned that I do not want to have to bail another photographer out of a mess. I want to make my own mistakes and clean up my own messes," she said. "One partner wanted to hire a staff of photographers to do all the jobs and the other partner couldn't let go of that control to hire other photographers. The partnership was trying to take the business into two different directions. The only smart thing to do was to dissolve that partnership and to begin again, each with our own vision."

Nancy decided she was going to do what she wanted to do and do it the way she wanted to do it. The first thing she did was relocate to a smaller studio. Then she cut her work load back forty per-

23

TOP: *Inside front door.*
BOTTOM: *Front reception room.*
*Door leads to office/work area.*

*TOP: Employee office/work area. BOTTOM: Completed orders are stored in the office/work area located just off the front reception room.*

cent and raised her prices to compensate. Where she used to personally photograph as many as seventy-eight full-length New England weddings, now she photographs only forty. She also cut back on the high school contracts and all the low end photography that was labor intensive and low profit.

"After twenty years in the business in Plymouth, I have established a clientele who know the quality of my work. They are willing to pay for that quality—whether the economy is good or bad," she said, adding, "Once you have had the best, you are not going to go backwards."

Downsizing meant relocating to a 4,000 square foot building with no extra rental property. "It was a big metal building with ten-foot ceilings, fluorescent lights and a cement floor covered with thin commercial grade carpeting," she explained. "The best part about it is I don't own it so I don't have the headache and the hassle that go with owning a big commercial property." Nancy used her hobby, what she calls creating detailed architectural drawings of dream homes that she will never move into, to design her new studio layout.

"The number one objective was to make it feel like a home. I wanted clients to feel like they were coming to visit a friend," Nancy said. She created a living room setting in the front entranceway, complete with lots of plants, soft lighting, cushy sofas and large family and wedding portraits beautifully framed.

*LEFT: The high key area of the camera room includes a complete selection of white props to provide clients with a wide range of portrait styles.*
*BOTTOM: Nancy's camera room includes a television monitor as part of her digital capture system.*

"I wanted to emphasize the feeling of family. After all, without the family, you wouldn't be having portraits made. It is rare for someone to make a portrait just for himself. We have portraits made to give to our families," she added.

She situated her camera room at the new location right up front near the reception room. Nancy explained, "I have a very loud voice and I purposely laugh a lot. People sitting out front hear my laughter and cannot help but think it sounds like we are having a good time. They can't hear what I am saying, but they can hear the laughter, and laughter is contagious." Her monster studio had the camera rooms at the back, and Nancy noticed clients would get nervous as they walked down that long hallway to the camera room. By keeping the camera room up front, they have no time to get nervous.

Nancy considers it important for every room in her studio to be fresh and clean. "You don't want people wondering who has been there before them," Nancy said. She even buys sugar cookie candles so the studio smells like home baking.

ABOVE: *The garden shooting area is just steps away from the studio.*

26

# Separate But Equal

Julia Russell and Jay Goldsmith have operated separate but equal businesses out of the same building in the seaport town of Portsmouth, New Hampshire since 1985. They were each running their own independent photography businesses when they met, and they decided that merging on a personal basis did not have to mean merging on a business basis as well. The separate but equal business arrangement has been working ever since. Julia does one hundred percent weddings, while Jay does one hundred percent outdoor portraits of families and children.

*BELOW: Julia wanted a rich, English look to tie in with her love of England.*

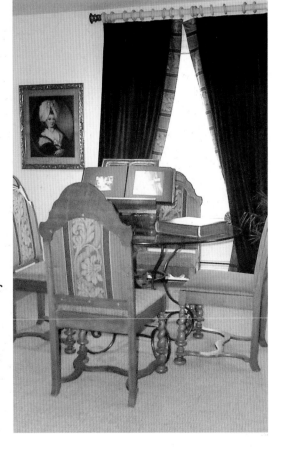

Their studio is located on a residential side street in a New Englander/Victorian style home that was built around 1900. Julia explained that the outside styling is more New Englander, but the interior is

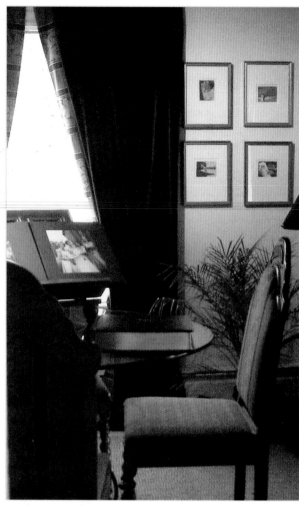

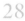

*LEFT: Julia collected the teapots in their travels to England. The corner cabinet is originally from England and Julia purchased it at her favorite place to go antiquing, the annual Brimfield Antique Market in Brimfield, Massachusetts. RIGHT: The only photographic wall decor in Julia's room is a grouping of four framed Polaroid transfer images, one of Julia's signature photographic styles.*

classic Victorian. They lived in the home the first eight years until their businesses outgrew the space. Julia and Jay gave the studio over to the clients and relocated their personal living space to a home about a mile and a half away.

"We had to move the business or move ourselves because there was no longer room for both," Julia said, adding that their low volume businesses place little impact on the surrounding neighbors.

Jay uses the largest room in the house, what was once a living room, as his combination salesroom and gallery. His sales of family portraits are geared toward 20"x24" and larger framed wall portraits, so he needs the large wall space to showcase his portraits. (Julia, on the other hand, sells mostly wedding albums and very few larger portraits.) "I assume from the beginning that every client is going to purchase a 20"x24"

or larger portrait. Everyone has room in their home for that size, and it also makes the sale worthwhile for me," he explained. He uses the samples in the gallery during the planning consultations to display his photographic style and to give clients ideas on clothing to wear for their own portrait session.

He prefers simple, clean lines for his decor. It matches his personality and also keeps the attention on the work itself and not the furniture.

Julia uses the small room off the front hall just inside the front door. Because she rarely meets with more than two people at once (the bride and groom), the small room adds a feeling of intimacy to her interviews. The newly redecorated room reflects her personality. Julia said she was inspired to transform her sales room after reading a quotation that was enclosed in a birthday card from a another photographer. The quote spoke about the magic and illusion of a photography studio, and the importance of including personal items in the studio that show the photographer and not just the photographs. Julia said she realized she needed to put more of herself into the studio so it would be more a reflection of Julia the person and not just Julia the photographer.

She hired a decorator and explained she wanted a more upscale feeling to her office to match the upscale clients who

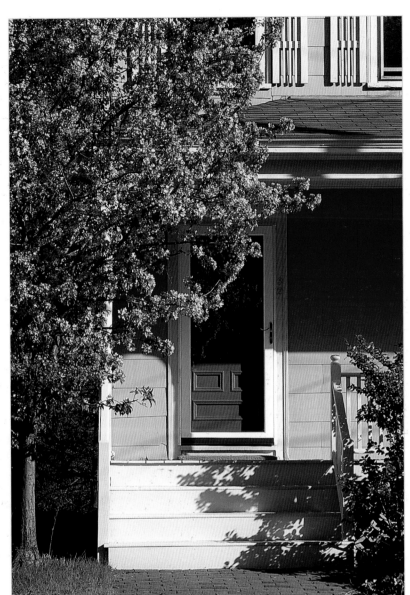

*ABOVE: Front door to the shared studio.*

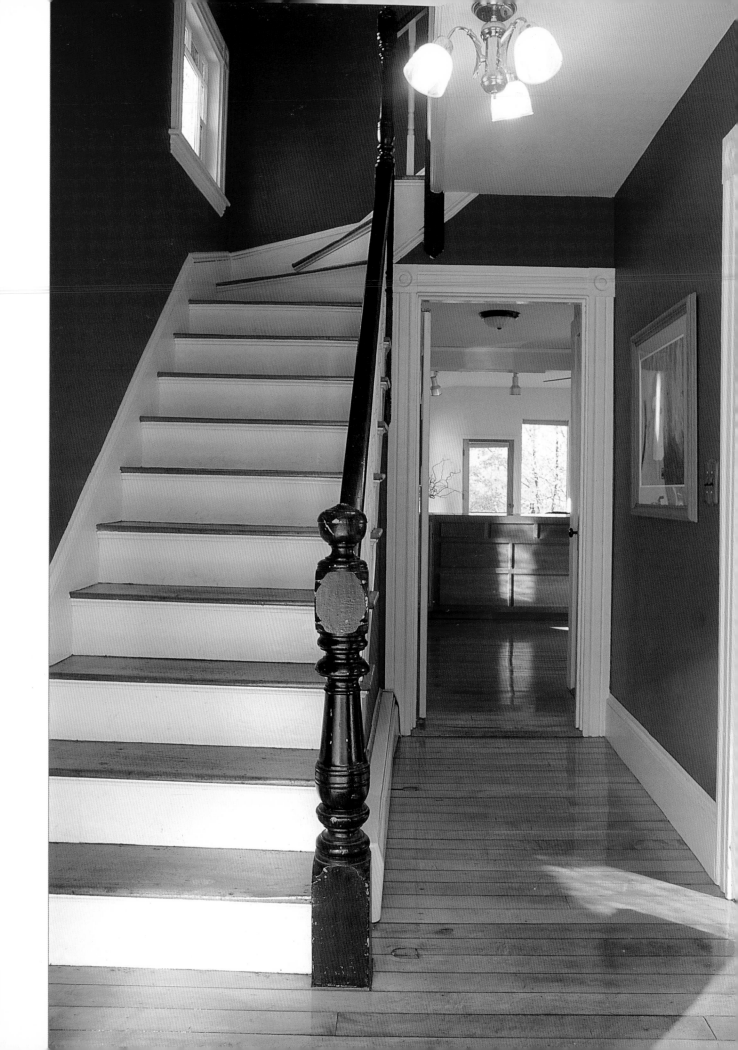

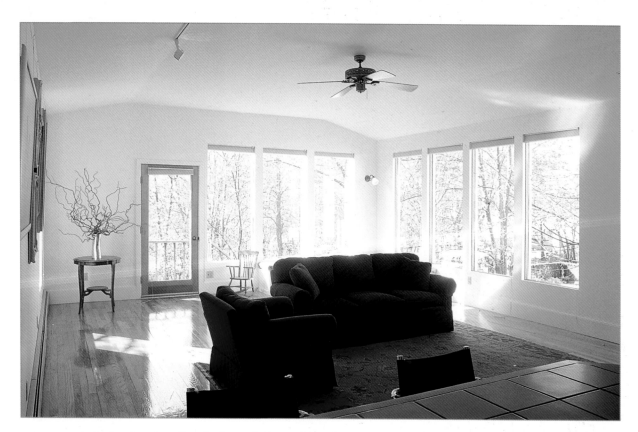

were commissioning her for their weddings. She also wanted to tie in her personal love of England. "The decorator brought in swatches of fabric and then later faxed me a proposal much like I would present a proposal to my own clients," Julia said, adding, "It is important to hire professionals because they can envision things that the amateur cannot."

Part of Julia's decor revolves around the product she sells: wedding albums. She explained, "I have to be very careful with what I display in my room to make sure it does not detract from what Jay is doing in his room. Jay sells large and I sell small. If his clients see a lot of small portraits on my walls as they glance into my room on their way to his, it might detract from what they choose to buy from Jay.

"Also, I don't want to bombard my clients with thousands of pictures because much of what I am selling is myself. That is why I show personal things in my viewing room. I want clients to know who I am," she added. Julia shows clients three albums, one from each of the three finishes that she offers (leather bound, custom-made cloth bound from a book

*ABOVE: Two banks of windows give a bright, spacious feeling to Jay's viewing room. The furniture is simple to keep the focus on the portraits.*
*OPPOSITE: Front hallway. Stairs lead to their offices, and the hallway leads to Jay's gallery showroom. Julia's room is just off the right of the front entrance.*

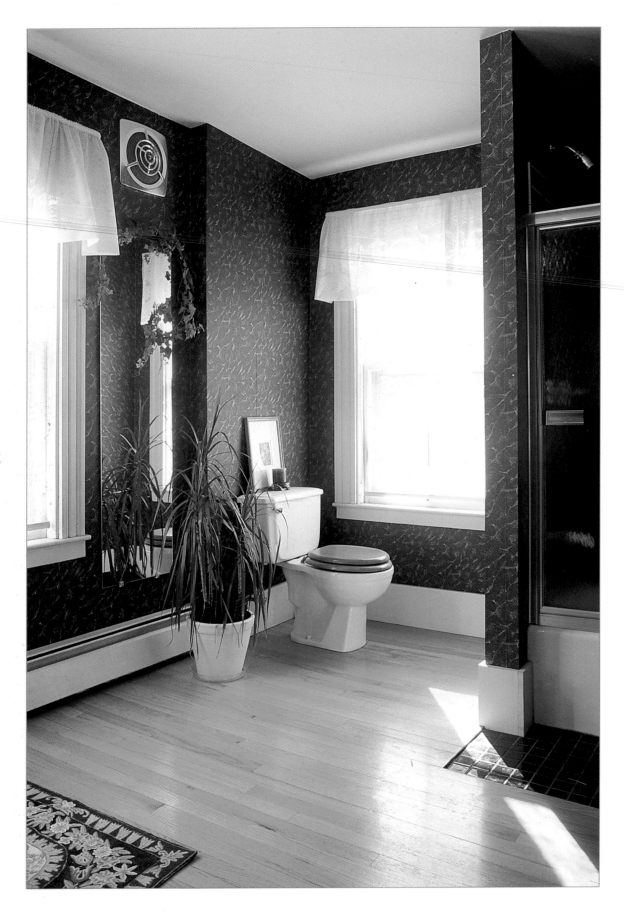

bindery and custom-made cloth bound portfolio box with 11"x14" mats that have 5"x7" openings). Her only wall decor is a painting that once hung in her mother's bedroom and a collection of four Polaroid transfer portraits (one of Julia's portrait specialities). Of her limited examples, Julia said, "I don't want them to get burned out on looking at tons of pictures. I want to make a personal connection with the people as individuals and as a couple. I show samples of my style. Either they like my photographic style, or they don't."

Jay said separate spaces and separate phone lines are important factors for running two separate businesses under one roof. "Before we had separate phone lines, half the calls would be for me and half for Julia. I didn't know how to answer her clients' questions and she didn't know how to answer mine. It was very unprofessional, and it made a world of difference when we went to separate phone lines," he said.

In addition to the separate sales rooms, they also have

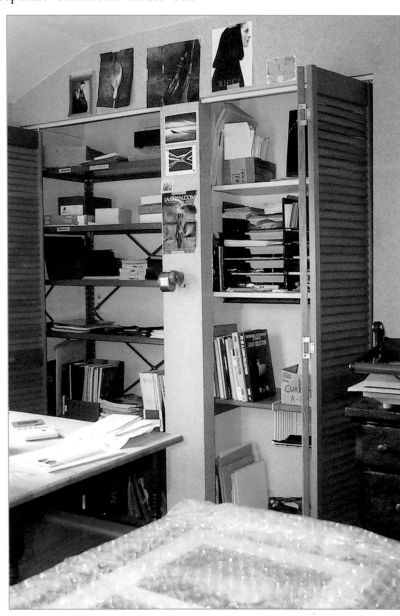

*RIGHT: Jay's office includes a desk, computer station, supply shelf built into the former bedroom closet, a small mounting press on a chest of drawers and a mat cutter on the work table. He posts photographs he likes from magazine ads above the closet door to inspire him for future portrait projects. OPPOSITE: The bathroom is nicely appointed to ensure clients feel welcome.*

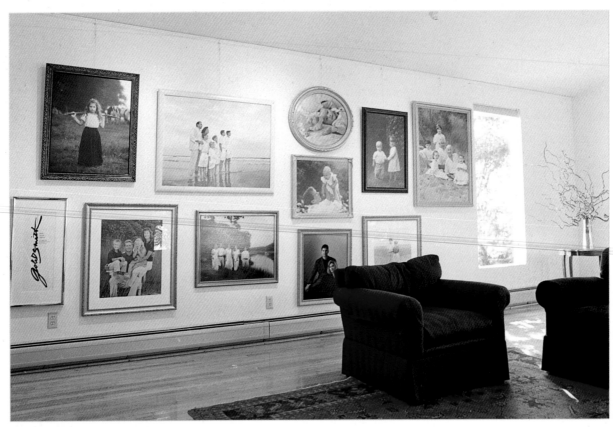

34 *ABOVE: The left wall of Jay's room serves as his gallery. He uses the samples to show portrait style and clothing suggestions before the session and to show sizes and shapes during the viewing session after the shoot.*

separate offices. "We keep separate offices because we have very different personalities," Julia said, adding, "He is very neat and streamlined, and I have a tendency to lose track of things."

Splitting overhead costs is an obvious benefit for sharing the same space. Julia and Jay also share clients. "If they are satisfied clients of Jay's and they have a daughter getting married, they will naturally think of me first. Jay also gets the babies from my marriages," she said. Jay added, "We both appeal to the same socioeconomic segment. If I was a high volume, low price oriented operation and she was an upscale wedding photographer, the combination of businesses under one roof would not work."

# Urban
# Sprawl

# New York City, Second Generation

Andy Marcus is a second generation photographer at Fred Marcus Photography in the heart of New York City. He started assisting with weddings when he was thirteen years old. After earning a degree in economics, he came back to the family business to pursue his love affair with weddings.

*BELOW: Front entrance to the studio.*

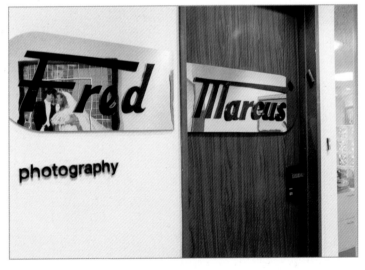

The studio is located on three levels in the small apartment building where it originally opened back in 1941. Andy redesigned the present decor from scratch to suit his client base and to maximize the limited space available. "This is not my ideal studio," he said, adding, "But it works very well

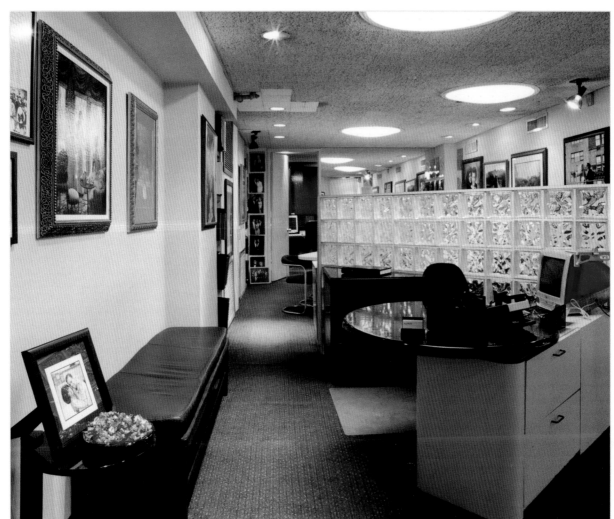

when you consider the volume we do here." The studio actually originated in the basement of the building and gradually grew upwards as space became available.

The lower level is now production area for the staff. The 2200 square foot street level area is divided into three distinct sales areas for semiprivate consultations. The upstairs floor is basically a studio apartment where they photograph families, executives and children.

He has eighteen full-time staff, but that number swells to nearly fifty when he counts all the photographers and photography assistants who work the weekend wedding shift. The staff includes three sales people (including himself), a receptionist, an executive assistant, and two employees who do nothing but coordinate the weekend weddings and the staff

*ABOVE: Receptionist area just inside the front door. Walls created out of glass blocks add semiprivate dividers while still giving the room an open feeling.*

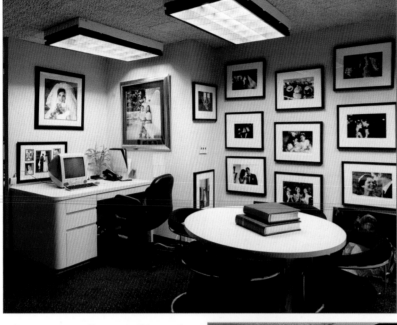

*ABOVE AND RIGHT: To make the most of the limited space, the walls are covered with sample photographs.*

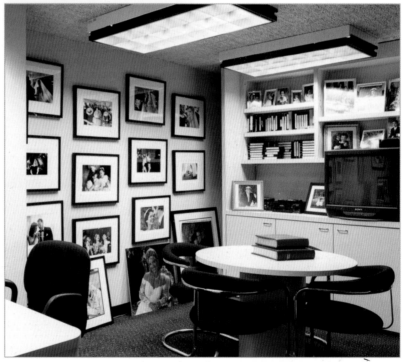

that photographs those weddings. The rest are production assistants, photographers or wedding assistants.

Andy said the most important aspect of any studio decor is to work with a professional decorator. He had a basic idea of what he wanted to accomplish, but he left it up to the decorator to ensure it was done professionally. He said, "A professional decorator will give you the most for your decor and a

professional space planner will get you the most out of your actual space." He hired both.

He chose a contemporary style of decor to match his upscale New York City clients. To get the most out of his tight space, he used V-shaped walls made out of glass blocks. The blocks are translucent, allowing light through and making the smaller space feel more spacious.

Building space isn't the only thing at a premium at Fred Marcus Photography. Booking space is limited too. "With all the engagements that take place over the holidays, January is the busiest month to book weddings. The phone never stops ringing. It is not uncommon for us to book 100 parties during January," Andy said. To stretch those dates as far as possible before he must outright reject a job, Andy suggests clients follow the trend in New York City and get married on Thursday.

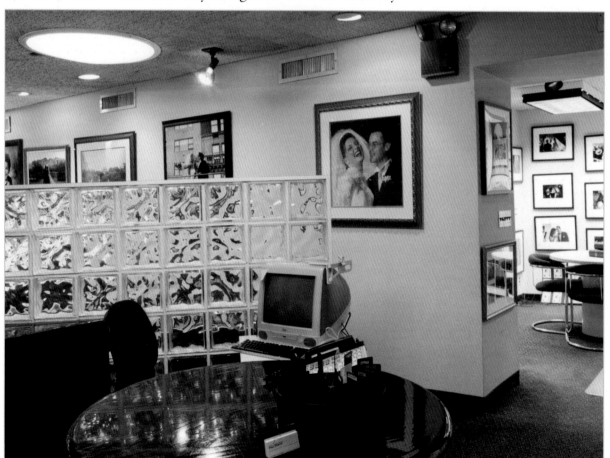

ABOVE: *Consulting with a professional decorator and space planner helped maximize the style and efficiency of the studio's limited space.*

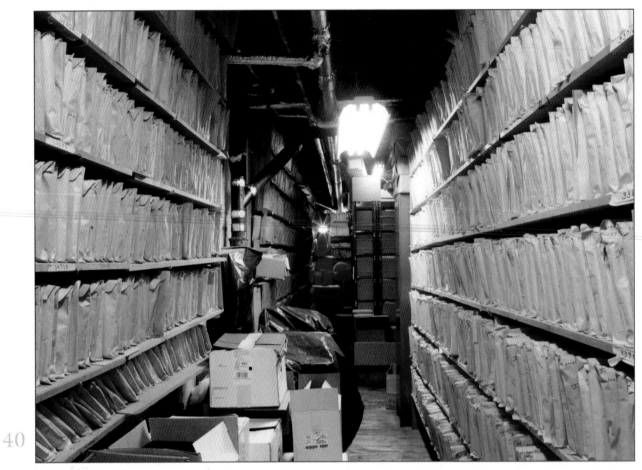

40

*ABOVE: Negative storage space is provided for in the studio's basement.*

He said, "Getting married on Thursday is great all around. The couples don't interrupt their guest's weekends and they have more choices on booking the best bands, the best hotels, the best musicians and the best photographer." Fred Marcus Photography photographs five hundred weddings per year. During the prime time months, there could be twenty to twenty-five functions on any given weekend.

# Dream Studio

Alvin Gee began his wedding and portrait photography business with the humble beginnings typical for many photographers. Twenty years later, in 1999, he built his ultimate dream studio on the west side of Houston, Texas.

*ABOVE: Alvin Gee's business portrait was photographed at the edge of his studio's grand staircase with the procession-al gallery hallway located behind.*

"For many years I had dreamed of designing my ideal studio. I wanted an environment that included all the special elements I had gathered from a decade of hosting photography programs and of visiting studios across the country," he said, adding, "I wanted to raise the level of my professional image and to create a first-class impression upon my clients. When clients visited my studio, I wanted them to feel they were visiting someone with both artistic talent and discriminating taste."

He said location was one of the most important considerations to his future growth and success. Alvin bought an 8,000 square foot building located next to Houston's prestigious

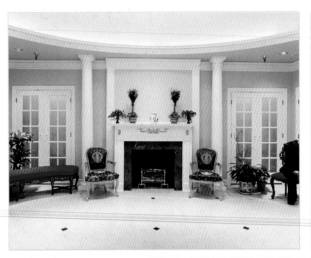 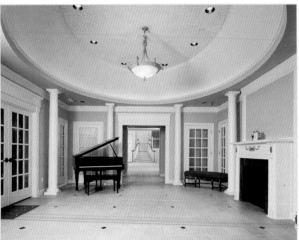

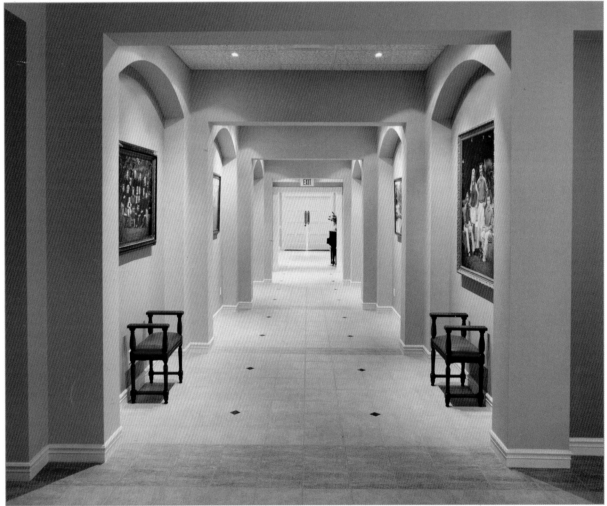

TOP, LEFT: *The inside foyer includes french doors and a marble-inlaid fireplace.*
TOP, RIGHT: *The foyer ceiling was designed to be architecturally stunning. It is lit with neon lights that create a warm glow that is reflected off the limestone floor.*
BOTTOM: *Processional hallway leads to the gallery room. It gradually becomes both wider and taller.*

Town and Country Mall, home to Neiman-Marcus and Saks Fifth Avenue. His studio is also located in the heart of the Memorial Villages, one of the largest and most affluent residential areas in the United States. Alvin spent two months working with an architect and another four months overseeing the renovations that transformed the basic box building into his dream studio. It includes 4,700 square feet for the studio and 3,300 square feet for storage and lease space.

The inside foyer area first impacts clients as they enter the studio. It is a rectangular room with an oval illusion domed ceiling, supported by a colonnade of nine-foot-tall white columns which are interspaced with French doors and windows. The dome's neon cove lighting creates a warm glow that

*BELOW: Reception room overview. Alvin uses the reception room to consult with clients, as a waiting area before a portrait session and as a gallery to showcase his portraits.*

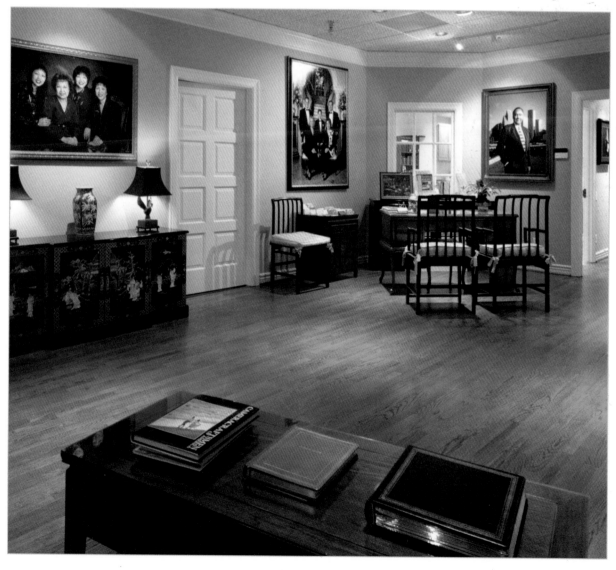

is reflected off the limestone floor. Accessories in the room include an alabaster chandelier, a black baby grand piano and a fireplace that is inlaid with green marble.

What Alvin calls his formal processional hallway connects the foyer to a cascading staircase located in the main studio gallery. He uses the hallway as a gallery to display many of his wall portraits. The hallway has a forced perspective. The walls gradually become wider and the ceiling gradually becomes higher, leading to the grand staircase. Those stairs serve several purposes. They offer a dramatic focal point for the room, serve as an elegant setting for bridal portraits, act as a prop when photographing family groups and lead to 1,500 square feet of office space.

The reception area has antique flooring that Alvin rescued from an old house. The room is furnished with oriental rosewood pieces and antiques. The walls are hung with large canvas portraits that are individually spotlighted by halogen track lights with dimmer switches.

44

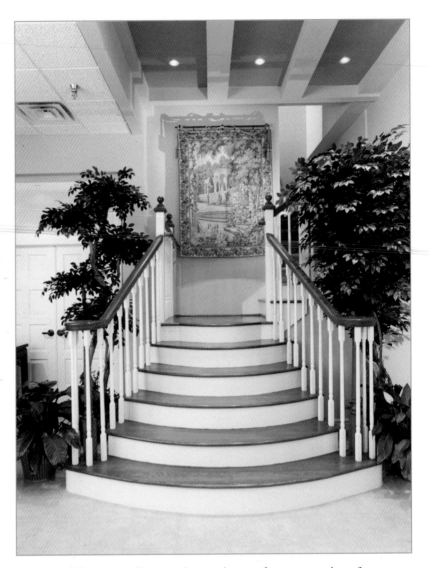

*ABOVE: The cascading staircase is an elegant setting for bridal portraits.*
*OPPOSITE, TOP: Alvin designed his camera room to accommodate groups of up to forty people.*
*OPPOSITE, BOTTOM: The interior hallway leads to the dressing rooms, a client pick-up room, the main production room and Alvin's personal office.*

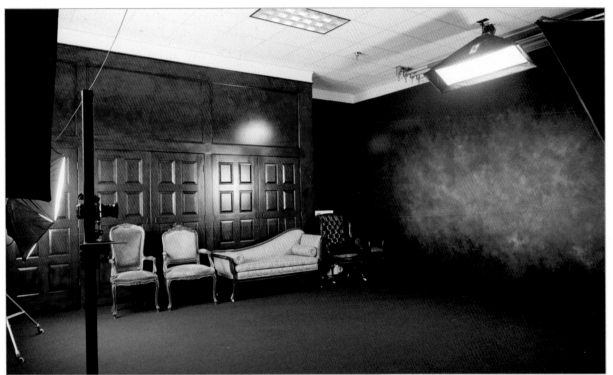
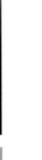

"I decorated the studio with antiques that I can use in my portrait sessions," he explained, adding, "I mixed the antiques with oriental and new classic pieces because I do not want the studio to look too stuffy. Understated elegance is the visual look of my studio." He also uses the hallway, fireplace and grand piano as settings for his portraiture.

Alvin included a children's room in his studio layout. It offers a TV/VCR and kid-sized beanbag chairs. Children can watch a video while their parents are making portrait selections in the projection room located just next door. He furnished the projection room with a sectional leather couch, and he built a see-through window to the children's room. Parents can view their portraits and keep track of their children at the same time. To make the portrait selection process easier, he had the projection room's screen wall made of a Velcro™-like material with removable pieces that can be positioned to illustrate how a portrait will look when presented as either a vertical or horizontal image.

*BELOW: Reception room close-up. Alvin also uses all the furniture and settings within the studio for portraiture.*

He also built two dressing rooms for clients. One dressing room is decorated for use by women, and the other is for men. Both include professional makeup lights and mirrors and clothing racks. The two rooms share a private client bathroom.

What Alvin calls his "working home" is a 24'x26' camera room with a 12' high ceiling. He commissioned background artists LaMarr Williamson to paint an ethereal 26' wide background in the Old Masters style. The colors

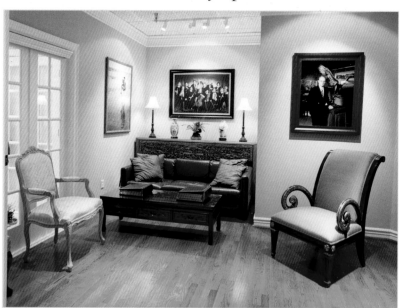

are teal and purple, and the background easily accommodates a forty person group portrait. The adjacent wall houses storage shelves that are hidden behind the 18' wide paneled doors

46

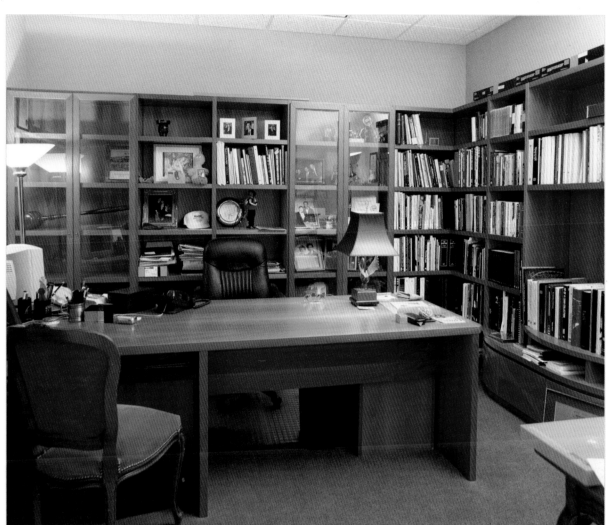

47

*ABOVE: Alvin's personal office.*

that he uses a background for many of the business portraits he creates for clients. He also has two bookcases filled with law books and accessories to complete the look.

His staff includes one additional full-time photographer as well as two full-time and one part-time office workers. They use two production areas. The first is in an 18'x24' room that includes a small kitchen and a lounge area. The second is located at the back of the studio and houses a 4'x8' work island in the center of the room that is used for frame inventory and assembly. The staff also uses the room for slide copying and negative retouching. He decorated his personal office with a teak desk and built-in bookshelves. He said he filled the shelves with inspirational books, motivational books and books about fine art that he reads to enhance his spiritual and creative self.

Alvin said buying the building and doubling his studio space exhilarated him and sparked his creativity. He also said the single most important factor to "taking the plunge" was establishing a budget and then having the discipline to stick to that budget. The end result was more than worth the investment. "Environment plays a large part of a person's mental state. My clients are impressed with my studio and walk away knowing that I am serious about photography," Alvin said, adding, "I work at what I love and I bring joy to my clients. Now I am doubly blessed to create artful memories in the studio of my dreams."

*BELOW: The Gee children, Sarah and Travis, help in the production room during the summer. Alvin's wife, Janice, works full-time as a certified public accountant in the corporate world. She is secretary/treasurer of Alvin Gee Photography, Inc.*

ELIZABETH HOMAN

# Homey Professional

When Elizabeth Homan's parents gave her permission to operate her new portrait and wedding photography business out of their San Antonio, Texas home in 1992, they had no idea that studio would ultimately take over virtually every room in their home other than their bedroom. Elizabeth remembered, "After the first two years there were too many customers coming and going, and my parents had absolutely no privacy. The studio had literally taken over their five bedroom home."

*ABOVE: Elizabeth Homan at work.*

"I wanted the new location for Artistic Images to look like a home, and I wanted it to have that homey feeling," Elizabeth said, adding, "But I definitely wanted clients to know it was a professional office space." Elizabeth's "must-have" criteria for the new studio included: a large window for photographing available light portraits, a large camera room with a ceiling ten

feet or more, sufficient grounds for outdoor portrait sessions and enough office and production space to accommodate at least five workers. When she couldn't find suitable space at local shopping malls or business centers, she decided to buy land and build.

Her original plan was a single story Victorian style home, but with the roof and the foundation being the two most expensive factors, she dramatically cut costs by switching from a one story plan to a two (less foundation and less roof).

She chose Victorian country for her decor theme. It goes with the building style and it also matches her clients' tastes. Elizabeth chose dark colors that have a rich feeling. Hunter green, navy blue and gold are the dominate colors throughout the studio. Much of the furniture is upholstered with floral fabrics to lend a light, happy feeling to the rooms. Elizabeth hired an interior decorator to coordinate draperies to tie in the colors and the decor style. "I gave her an idea of what I was looking for, and then I let her go to it and do her thing," she said.

Her studio is divided so that most of the client areas are on the ground floor while her production areas and offices are on the second floor. Each type of client has its own sales room, including weddings, high school seniors and family groups. "I didn't want

*TOP: The 3600 square foot studio looks like a home, but it is entirely devoted to the studio.*
*BOTTOM: The sign sets the mood for the homey but professional feeling Artistic Images projects.*

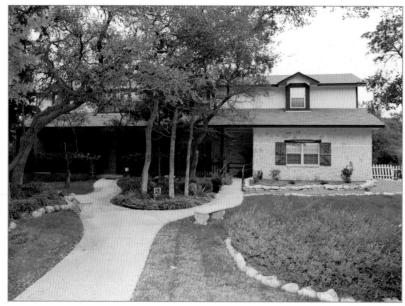

50

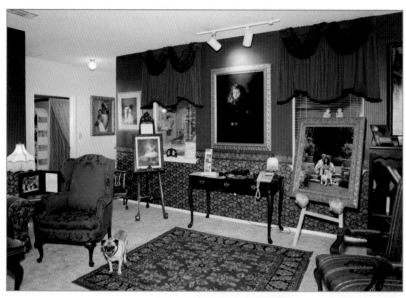

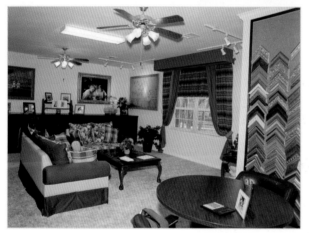

to group all the samples together from our different portrait offerings because each one has its own strong style," Elizabeth explained.

She originally built her sales room too small, and Artistic Images quickly outgrew the 11'x14' space. Two years later, she added a 25'x20' addition for a new sales room. It included built-in mahogany cabinets for storage, a screen that comes down over the large picture window for projecting previews during the sales session, and floral couches to tie in with the decor of the rest of the studio. The old sales room became a backup, used primarily to do sales from promotional sittings.

"I wanted the overall effect of the studio to have a homey and inviting feeling so clients would feel like they could sit back and relax," she said, adding, "The actual quality of the fixtures

*TOP: A comfortable parlor greets clients when they enter the front door. Pugsley, Elizabeth's Chinese Pug, is likely to greet clients too. BOTTOM, LEFT: Elizabeth uses slide proofs to show clients their portrait images in her newly added sales room. Sample portraits on the walls are 30"x40"–40"x60". BOTTOM, RIGHT: The production room is on the second floor.*

and furniture lets clients know we are a quality studio. I also wanted to send the message that our portraits should be viewed in the same way they would select fine furniture."

Elizabeth's advice for new studio owners is simple. "Stay at home as long as you can, and keep your business operation by appointment only. When you start to get a lot of traffic, that is when you know you need to move your studio to a new location." Her parents, Sterling and Penny, continue to work with Elizabeth. However, now when they clock out at the end of the day to go home, they actually have a home to go to.

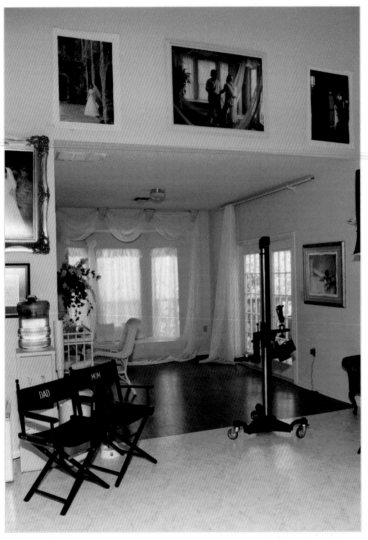

*TOP: The window light area of the camera room is Elizabeth's favorite place. The soft North light makes it ideal for photographing babies, mother-child and children.*
*BOTTOM, LEFT: High school seniors have their own room, complete with a popcorn popper for an after school snack. The frame room is located in the next room.*
*BOTTOM, RIGHT: Pugsley, the studio mascot, is well-loved by children and adults alike.*

# Honolulu Prime

Dwight and Kay Okumoto operate their portrait and wedding photography business in the heart of Honolulu. They opened their first studio in 1978 in their home, and moved to this prime location in 1986. With rental space at a premium, they must make every inch count in their 1,000 square foot location. The camera room takes up 650 square feet, and the remaining space is divided between the reception room, hallway, front desk area and a small sales room.

*ABOVE: Studio 3 sign in front of Dwight and Kay Okumoto's Honolulu studio.*

"To make it look bigger, we designed the entryway and reception area with lots of angles. If it was all in a straight

*ABOVE: The view from the reception desk to the front door. Notice the angled walls.*
*LEFT: Clients see this view first as they walk down the entry hallway.*

line, the room would look a lot smaller," Dwight said, adding, "The angles also give you more wall space to display sample portraits."

They take advantage of the limited wall space by literally filling the walls with photographs. "We want the samples to be

fun shots of families and creative sets and poses of high school seniors," Kay explained. They change the photos with the seasons to ensure the most current work is on display.

"By continually updating the samples, particularly with seniors, it keeps them fresh and shows off our most current work," Dwight said. "It also serves as an endorsement when seniors see familiar faces on the wall from their own graduation year," he added.

The husband-wife team prefers a clean, light feeling for decor. They painted the walls light grey and added a pale pinky-salmon for the trim to appeal to their client base, which is primarily female. The contemporary chairs in the waiting area tie in both colors.

"We want clients to feel a sense of welcome when they walk through our front door. We want them to feel comfortable enough to look around and enjoy our portraits," Kay said. Their receptionist greets clients, offers to help and then gives them the freedom to relax and browse.

To say their consultation room is small is an understatement. Kay said it is a 6'x9' "closet." They use it for planning sessions for families and weddings. To give clients a sense of being special and important, they designed the room so you must step up. The decor includes a love seat, a table, a side chair and

*TOP: Limited space means making every display inch count. Notice the ledge that doubles as an area for displaying samples. BOTTOM: Products behind the front counter serve to show samples and items, like folios, to purchase.*

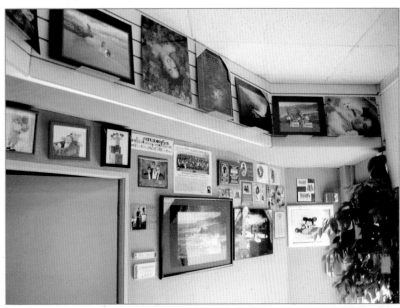

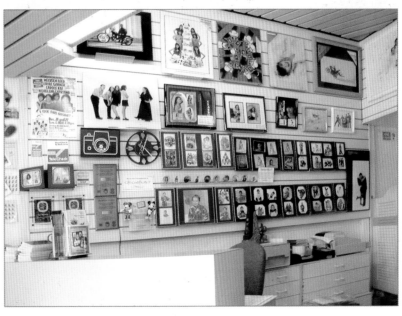

plenty of samples. To help prevent clients from feeling cramped, they put large tinted windows on two sides of the small room. Clients can look out and see a larger space, but no one can invade their privacy by looking in.

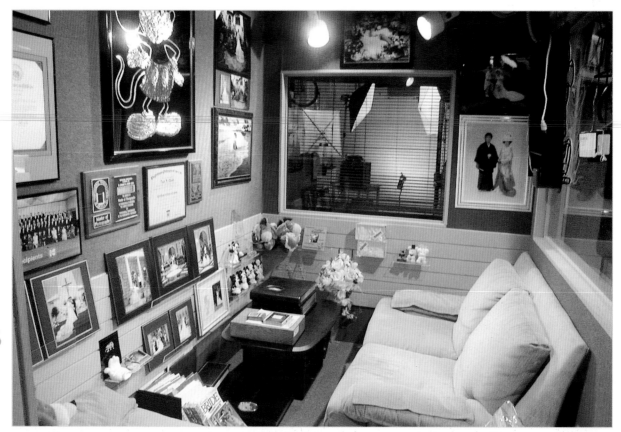

*ABOVE: The 6'x9' sales room has tinted windows to allow clients to look out, making the room appear larger. Notice the Mickey Mouse on the wall. Kay collects them, and has several throughout the studio to give it her personal touch. RIGHT: The camera room is only 650 square feet. Dwight hangs props from the ceilings to maximize his limited space.*

# L.A. High Rise

Gary and Marci Fong operate Storybook Studio and Gallery from the third floor of a sixteen-story office building in Los Angeles. Situated between the Marriott and the Hilton Hotel, he says they literally order room service from the Hilton when they are working late into the evening with clients.

Aside from their prominent studio location, Gary and Marci are not easy to find. They do no advertising and no marketing. There is no sign on the front door of the studio location, and they are not listed in the Yellow Pages. Their multi-page interactive web site (www.storybookweddings.com) showcases their photography and their studio. All of their business is generated strictly by referral. New clients are the relatives, friends, guests and bridesmaids of couples Gary and Marci have previously photographed.

*ABOVE: Exterior of studio location.*

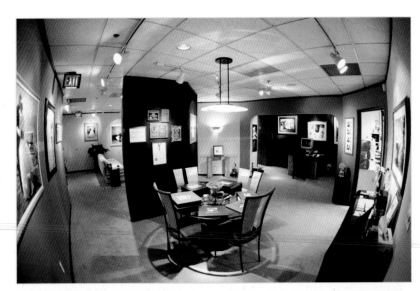

*RIGHT: Gallery area in the reception room. BELOW: The opposite view from the gallery room. Notice the open walls to the right.*

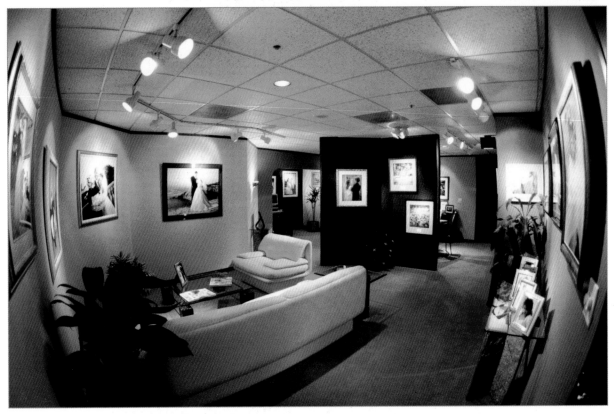

58

When new clients do walk through their front door, the Fongs want the first impression to be "Wow." Gary said the single most important factor of his studio is what the clients see when they open the front door and first enter the studio. "Outside of the basic 'make it look nice,' impact is the most important design factor. We didn't want clients to walk in and see a small foyer-type entry room and then have them walk to

the main gallery room. We wanted them to be impressed as soon as they walked through the front door," Gary explained. Clients can see forty feet from the doorstep of Storybook Studio.

To enhance the spacious feeling, the Fongs designed the studio to resemble a great room. There are walls, but no doors that close. That open feeling gives clients plenty of areas to view when they first arrive at the studio. It also serves as a sales tool. Gary explained, "We try to schedule new interviews with prospective couples at the same time that we are delivering a completed album to another couple. The new client will overhear the other one exclaiming how great their pictures are and how we are worth much more than what they paid." Marci said this is the best 'advertising' they could possible get, and it is all done just by timing the delivery of the completed album to coincide with new clients coming to view the Fong's samples for the first time.

*TOP: The free-standing wall is painted black to add drama and to make the photographs stand out.*
*CENTER: The theater area is where couples and their guests view the wedding images for the first time. The computer-generated presentation unfolds as a "virtual reality" of the custom designed wedding album in storybook style.*
*BOTTOM: Production area.*

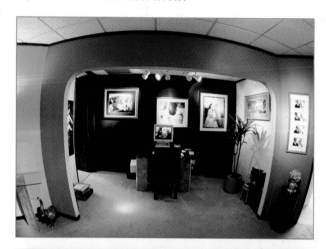

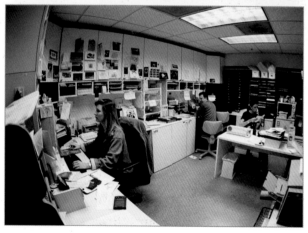

They painted the walls with bold colors (black, deep purple and grey) to enhance the feeling of impact and to draw attention to the photographs. "We used black on the middle divider and on the back of the alcove to make the images stand out," Gary said, adding, "The rule is you do not use black for walls because it makes things look too dark and too closed in, but that is not necessarily true. We have an entire room at our house painted black, and it really opens the space up because it literally looks like space." Marci describes the studio decor style as opulent but comfortable.

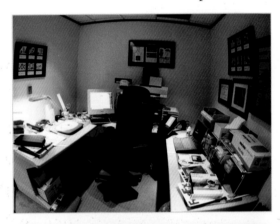

*TOP: Office space.
BOTTOM: Negative storage
for nearly twenty years of
wedding photography.*

The studio layout includes three separate presentation areas plus the theater room. Each area is in a separate "room" that is really just a part of the one great room. The first area is in the actual entry room when clients walk through the front door. The second area, what they call the North Gallery, is where clients view completed albums. It is also where new clients can view sample albums. The alcove section has a computer and the Fongs use this room to work with couples who are making the final selection for actual photographs to be included in their wedding album. Gary said, "A visiting photographer once commented that we have 'Zen walls,' meaning we have all open walls."

Marci and Gary use the theater room to present couples and their families the first viewing of the images from their wedding. They take anywhere from one to three thousand photographs during a wedding. The presentation includes about seventy percent of the images from the wedding day coverage, and they use a computer hooked up to an LCD projector to show the photographs on the wall. Gary explained, "We wanted to give brides and their families a spectacular show. The digital presentation is their virtual album. It is stunning and memorable."

# Greater New Orleans Trio

Ralph Romaguera operates his three studios in greater New Orleans with the help of his sons, Ralph Jr. and Ryan, and daughter-in-law Danielle. Their high school senior based business requires a full- and part-time staff of twenty-two, including three digital technicians, four photographers and three people working full-time in production. Many high school seniors work for Romaguera Photography on a part-time basis.

*ABOVE: Gretna studio reception area.*

Ralph Jr. runs the studio in La Place, two ladies run the Metairie studio, and Ralph Sr. and Ryan run the Gretna facility. Ralph Jr.'s wife, Danielle, heads up the marketing, management and accounting for all three studios. Ralph Sr. called the studios "similar but different." They photograph nearly 2,000 high school seniors a year over the three studios, both contract and

noncontract. They also do some family portraits as an offshoot from the senior business. In addition, they do the various proms and parties that go with the school market. "It is a ten and a half month senior photography season here. Our weather is hot and hotter. No downtime waiting for the snow to melt," he quipped.

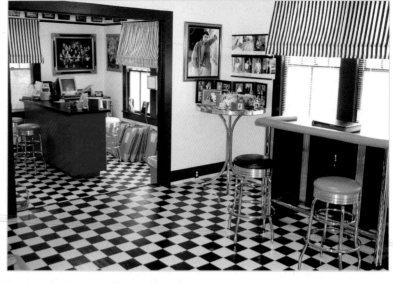

Romaguera Photography has been at its La Place location since 1984. Ralph Jr. gave it a face-lift with decor to match his laid back style. He decorated it

in the 1950s soda shop style, with black and white tiles on the floor, white walls with black trim, and soda shop type bar stools.

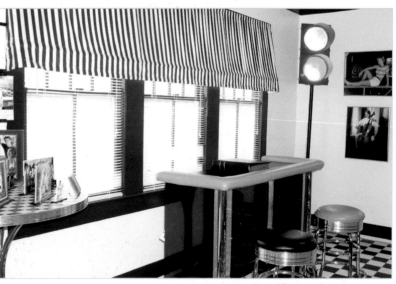

The entry room features entirely digital images on the walls and an old church pew painted bright red. The second room has bar stools and a real traffic light. Sample photographs are more traditional here, but old folding wooden theater seats keep the mood casual. Numerous outdoor sets make it easy to quickly photograph twenty to thirty seniors a day while providing lots of variety.

Ralph Sr. has the same outdoor set variety at his Gretna location. He said one of the main reasons he purchased the property in 1999 was because of the excellent outdoor property it included. There is a 30'x50' greenhouse, complete with a waterfall, making it possible to photograph "outdoors" rain or

*ABOVE: At the La Place location, a 1950's soda fountain theme creates a laid back atmosphere.*

shine. Other outdoor sets include two bridges, a barn, Off The Wall sets (a manufactured set of props that are made in Canada and marketed in the U.S.), a swing, and beautifully landscaped garden paths.

The variety of sets is a Romaguera Photography trademark that both La Place and Gretna locations follow. They average eight sets per senior session. "One of our sales goals is a folio for every client, and you cannot sell folios if you do not have variety," Ralph Sr. explained. "You need to change the camera

BELOW: *Outdoor sets are an important part of Romaguera Photography at the Gretna and La Place locations.*

angle, change the lighting, change the clothing or change the background. We try to never take the same image twice unless we know there is a blink." He trained his sons to photograph variety to fill those folios. They shoot four shots per outfit, including full-length, half-length, close-up and extreme close-up. Since they only take two images per set, each clothing choice has two background selections.

The third studio, located in an upscale neighborhood in Metairie on the "West Bank" of greater New Orleans, offers a conservative decor. The walls are dark teal and the furniture has a more traditional styling, leaning toward Victorian. Clients come to the Metairie studio for classic head and shoulders portraits of graduates wearing cap and gown or a tux for the boys and a drape

63

across the bodice for the girls. Romaguera Photography opened in Metairie in 1993 and has been at its present location since 1998.

Ralph Sr. said the key to working with family members is to teach them the basics and then allow them to be creative. "You have to allow your children to photograph and to market to how things are done today, and not like it was more than thirty years ago when I first started," he said, adding, "It is important that they work with you and not for you. Even though

64

*BELOW: Indoor studio at Gretna.*

I am the father, this is a team business. Now, we are all in this together." They meet every Wednesday morning to insure everyone is on the right track and to share input from all three studios.

Ryan is a new addition to the father-sons team, but Ralph Jr. has been photographing since he was thirteen years old. His father remembered, "We used to call him 'Ten Dollar Ralphy' because he would sell class reunion photos for $10 each. He would get dropped off at the job and then set up and shoot and sell all by himself."

Ralph Jr. said the key to following in your father's footsteps is to be patient and to learn everything you can before venturing off on an idea of your own. He said, "You should learn all you can learn and then go out and learn even more."

Both Ralphs agree it is critical to have someone dedicated to the business aspect of the business. Danielle began putting her marketing degree to use in 1997 when she took over the marketing and bookkeeping of the three studios. With as many as fifty sessions a day, that is no small task. Ralph Sr. said, "With someone else keeping the checkbook and watching over production, we can stay in the camera room where we should be. We can stick to the creative end and she can take care of the business."

# DAVID ZISER

# Metro Residential

Wedding and portrait photographer David Ziser has been operating his photography business out of his metro Cincinnati home since 1983. "I had done the fancy studio. I hated it, and my clients did too," he said. "I love having a residential studio and my clients say it is so much more comfortable." His home sits atop a hill with six stone lions lining the steps on the walkway up to the front door. David said it looks majestic from the outside, but feels lived-in from the inside.

*ABOVE: David Ziser's home studio is decked out for the holidays.*

He hired a decorator to do the living room decor for the main sales area. It has comfortable furniture, including a full-

sized sofa, three side chairs, and a fireplace that he lights during the winter months. His wall samples show the variety of portrait styles he offers and includes a 30"x40" portrait.

"You have to define what kind of a studio you want and then design your decor and your clientele to match," David said. As a single father raising two children, he operates the studio 8:30 a.m. to 3:30 p.m. Monday through Friday because that is when his children are at school. He does not take evening appointments. His only weekend jobs are photographing about thirty-five weddings per year. He said, "It was scary to set those hours, but the year we eliminated evening appointments was my best ever. My clients appreciated that I placed so much value on my family."

He follows through with the family theme when he meets with clients. "Almost all of my comments with clients during planning and sales sessions revolve around what their family is doing. We talk about the local PTA, what soccer team their kids play on and where they go for summer vacation," David said. "Talking about personal family stuff helps me to connect with them. We are not talking business per se. We are just spending time getting to know each other."

David makes another personal effort when it comes to delivering the completed portraits. He said it is not uncommon for him to meet a client at a hockey game where his own son is playing. "I want to make it easy for my clients to work with me, and I also want to give extra service to make the experience pleasant and memorable," he explained.

*BELOW: David uses his living room as the client sales and reception room. The fireplace adds a friendly touch during the winter months.*

66

He said he is not trying to run a traditional photography studio in the sense of booking every family or every bride who telephones the studio. "I want to control the quality of my clients by controlling which businesses I associate with," David said. For example, he has sample photographs displayed with the best florist, the best hotel, the best caterer and the best wedding consultant. He said, "I associate with those folks who have the image of being 'Cincinnati's Best.' As an example,

67

*ABOVE: The large television screen is an integral part of David's sales process.*

when I arrived at a wedding recently, the videographer said to me, 'Oh, I see they have hired the "A Team."' He meant the best caterer, the best florist and the best photographer."

David follows that quality concept through with his finished work. "I am a stickler for the quality of every image that leaves the studio, not only the photographic composition but also how each piece of photographic paper is printed. I don't want it to look a little too blue or a little too green. The printing must be perfect," he said, adding, "I flat-out tell my clients that each photograph is printed to my exact specifications. I won't settle for anything less."

DEBORAH AND ROY MADEARIS

# Dallas–Fort Worth Welcome

Deborah and Roy Madearis designed their wedding and children's photography portrait studio to make residents from the Dallas–Fort Worth Metroplex feel welcome. Madearis Studio was established in 1971 and they have been at their present Arlington studio since 1984. Roy calls their location, "the hyphen between Dallas and Fort Worth."

The free-standing building is located in a commercially zoned professional office section called "Old Town Village." The outside looks like a home, but the inside is strictly professional. "I don't want clients to get mixed up on whether or not this is a home or a business environment. I want it to look homey and inviting, but I want clients to know that this is a professional work space," Deborah explained.

*BELOW: The studio entrance is located on the back side of the building next to a spacious parking lot. Roy built this fake front porch as a portrait prop. Deborah uses her green thumb to maintain the gardens.*

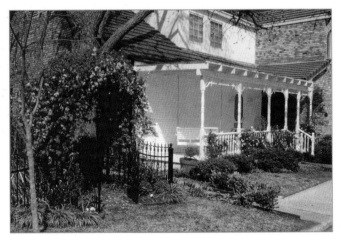

She also feels it is important to have the studio designed to meet the type of clientele you expect to photograph. Most of their clients are women, either brides or mothers. "We designed the dark, rich colors of the decor to appeal to the female in the family. Then we added the warm and fuzzy touches to complete the feminine appeal," Deborah said. They painted the walls bold cranberry and chose floral fabric for the furniture and drapes. The goal is for the studio to feel good, to smell good and to look good.

*TOP: The fireplace area is directly inside the front door in the reception room. BOTTOM: Looking to the left as you enter the reception room, you view Deborah's merchandising skills with her various product displays.*

"I want clients to walk in and sit down and be comfortable. The studio decor must touch their senses," Deborah said, adding, "We walk through the front door of the studio every day and look at our studio from the same perspective as the client. We pay attention to the little details like the windows being freshly polished and the carpets freshly vacuumed. It is like when you have company to your own home. You make sure you put out your best linen and your best china. We treat our clients like that special company." She offers ice cold bottled water or freshly brewed iced tea during the warm months and hot tea served in china cups when it is cold.

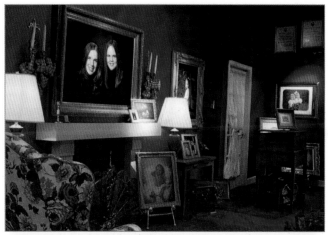

69

Roy explained that their main concern with the decor is that clients know they are welcome from the minute they arrive in the parking lot. They want the feeling to be homey, but the mood to be professional. Part of that homey feeling is making sure to take time with every client. Deborah explained, "We never want any

of our clients to feel rushed. We always make them feel like we have all the time in the world."

The interior rooms are divided into separate sales areas to appeal to their distinctly different types of clients. They have a

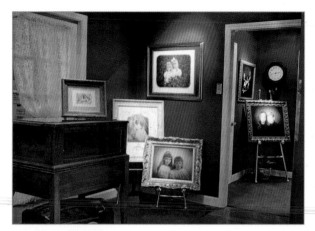

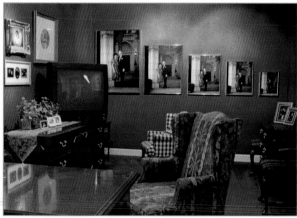

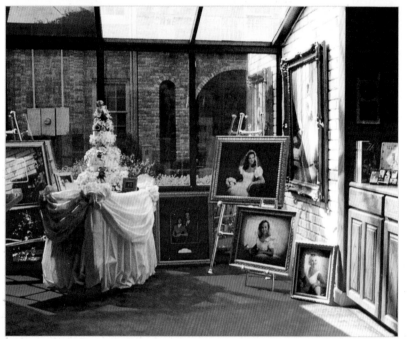

*ABOVE, LEFT: Deborah uses every corner of the studio to display portraits.*
*ABOVE, RIGHT: The portrait sales room features one wall with the same portrait displayed in a full range of sizes, from 30"x40" down to 11"x14".*
*LEFT: All the displays in the wedding sales room appeal directly to the target audience—brides.*

room for brides, a room for children, a room for families, and a room for general browsing. "If you choose to go after the children's photography market, then you had better be ready for kids when they walk through your front door," Roy said. Their main sales room has a separate room for children. It includes a television and VCR, storybooks, miniature wing-backed chairs, and a selection of Disney movies. Deborah explained, "Children know they can go in the room and feel comfortable. It is a nice place, a 'mind-your-manners place,' but it is also a very comfortable place for kids."

Targeting to the bridal market is an important element to Madearis Studio's success. Not only do they want to photo-

graph the weddings, they also want to sell brides the entire selection of their bridal accessories (i.e., garter, cake top, invitations, guest book). "We make sure clients know that we are not photographing weddings because we have to but because we want to," Roy emphasized.

To support that target market, they have a separate bridal room. It includes many sample wedding albums and wall portraits as well as a complete selection of the wedding accessories. Roy said it is not uncommon for brides to make fifteen percent of their total purchases with Madearis Studio on these wedding accessories. "This is stuff the brides are going to buy anyway," explained Deborah. They make it easy to buy by providing a beautiful room and a full line of merchandise.

"With whatever products you decide to sell, you need to make sure your clients feel comfortable enough to rummage through your samples," the merchandise-oriented studio owner explained. "If you can get clients to pick up the products, feel them, really look at them, you will have a sale. We merchandise all our products to encourage clients to touch," she added.

*TOP: Roy made the custom cabinetry to show off Deborah's handiwork with the wedding merchandise displays. BOTTOM: Roy's personal office.*

Roy follows suit with his user-friendly L-shaped camera room. It includes a "window" set for "available light" portraits of babies against a white (high key) background and a dark setting for classic low key portraits. He built in fixed fill lights so he only has to adjust the main light and the fill takes care of itself. The low maintenance lighting setup enables him to spend more time working with his clients instead of fiddling with his equipment. He also built a fake Victorian styled porch at the rear of the studio. Located on the parking lot side of the building, it turned a plain brick wall into a welcoming

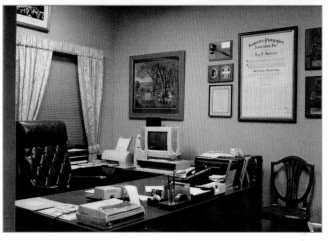

and very pretty prop. He uses it for photographing children, couples and family groups. (For further details on this subject, see *Family Portrait Photography*, by Helen T. Boursier, published by Amherst Media, Inc.)

Both Deborah and Roy agree, their basic business philosophy is to treat clients professionally, but make them feel the same welcome as honored guests. They use their decor to back up that feeling.

*LEFT: Everything is carefully marked at Madearis Studio, including the small props and toys used in the camera room.*

# Small Town U.S.A.

SANDRA AND GARY THIBEAULT

# Converted Garage

Since Sandra and Gary Thibeault opened their business in 1980, they have experienced the full range of studios—from working from an apartment, to moving to a loft area in a commercial building, to operating a storefront studio in a business district. In 1994, the couple renovated the attached two-car garage at their home and created a residential studio. Then they converted part of their basement for production and office space and moved their storefront main street studio into their home.

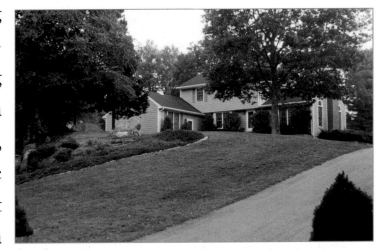

*ABOVE: The former garage on the left of the building is now the studio. The extensive yard and quiet neighborhood make the location ideal for a home studio.*

"When we first built this home in 1987 we had in mind that we might want to eventually bring our business home," Sandra said. The colonial style garrison home is located on a hill at the end of a cul de sac on a quiet residential street that

is just off the main road and near the post office. From their property, only one other home is in view. "We are easy to get to, but also secluded," she added.

They renovated the 24'x26' garage, designing it to keep the area open between the sales section and the camera room. It has a ten-foot cathedral ceiling to create a larger look. The sales side of the space was covered with blue carpeting, while the camera room side was carpeted with off-white. They use the same furniture they had at their commercial location.

"It all looks very homey. The mood is cozy and comfortable," Sandra said. Gary added, "It is easy for mothers to tell their children that they are going to 'go play at Gary and Sandra's house' because our business does look just like a home. The children feel safe and relaxed so it is easy to capture their natural expressions."

Another plus for the home studio is the easy access for environmental portraits. While their home was already beautifully landscaped, the couple also added a gazebo. There is a wooded area about half a mile away, and the beach is only three-quarters of a mile away.

"When we moved our studio to our home, our clients were thrilled," Sandra said. "They no longer had to fight for a parking space like they did at our downtown location. They no longer arrived windblown and rained on. Now they park right out front and come right in the front door."

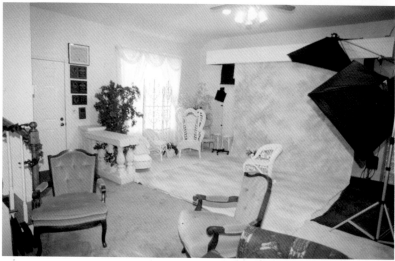

*TOP: A gazebo graces the property, creating a pretty set for children, families and brides.*
*BOTTOM: Studio interior.*

Gary likes the time they save by being in a residential studio. He explained, "You waste a lot of time when you have a storefront studio because a lot of people come in to browse who have no desire to have a portrait made. They are often just killing time, but they are coming into your studio and taking up your time. We would hang a sign on the front door that said we were with a client, but still people would bang on the door and demand our immediate attention." Now the studio is open by appointment only, and clients call ahead to ensure the Thibeaults expect them.

ABOVE: *The stairway leads to the client dressing room.*

Although they are open daytime hours Tuesday through Saturday and closed on Sunday and Monday, they will make an occasional exception. Gary explained, "When you have a home studio, it is not so bad to spend an hour or so working with a special client on your day off. Also, when you have a client that doesn't show up or that cancels at the last minute, it doesn't create the same kind of stress it did at the main street location."

Sandra is responsible for sales and marketing and she assists Gary with his photography sessions. Gary also does all the custom framing. His photography is fifty percent commercial (location and tabletop product photography), and he goes to those clients instead of asking them to come to him. He also does thirty percent portraits and twenty percent weddings.

"For a studio who is just starting out, the storefront location does give you that extra exposure," Gary said, but added, "You could take that money and put it toward your advertising and your direct mailings and get the same exposure." Sandra added, "If you do good quality work and you service your clients, they are going to come to you even if you are located way out in the boonies."

# Father-Son Studio Team

Alphonse and Thomas Micciche operate a father-son photography studio in a small town in central Massachusetts. Al's father opened the studio in 1935, and it has been at it's present location since 1937. The free-standing building includes two studios: one for their primary business of commercial photography, and a smaller studio for their wedding and portrait business. It also includes a computer lab and printing and processing labs for both color and black and white.

*ABOVE: Tom and Al Micciche working together to plan a commercial photography session.*

With two distinctly different types of clients (commercial and general portrait), Al said it is important to maintain two completely separate camera rooms. The reasons are both

78

*ABOVE: The commercial sales area includes only commercial samples.*

practical and personal. "It might take all day to set up for a difficult commercial product shoot that you might not actually photograph until the next day," Al said, adding, "Meanwhile, you may have a portrait session that you could and should do in between. Without the second camera room, you would have to break down your commercial set to photograph people."

Tom said it is also important for each type of client to have their own space. "Each one is a separate entity, commercial and portrait, so each one should feel special. We do this by giving them their own separate space." Their business is sixty-five percent commercial product photography and the remaining thirty-five percent divided between family groups, high school seniors and about a dozen weddings a year.

The separate setups make it easy for the father-son team to encourage commercial clients to participate in the photography setup and shoot. "A lot of commercial studios give the ad agency people a separate room away from the studio, but we want our commercial clients to participate in what we do. We don't want them to plug in their laptops, make business calls and forget about us," Tom said, adding, "We want them to know what it takes to do a commercial product shoot. We want them to understand how much work goes into each photograph so they can justify the money spent to the boss."

Tom said, "When the purchasing agent questions the expense, we always offer to let them come down and see what we do. Then, when they are walking out the door, they always say something like, 'You guys really have your work cut out for you.' After that, it is carte blanc."

Working one-on-one with clients also helps to establish rapport. That rapport leads to long-term business relationships. "We don't want a one-

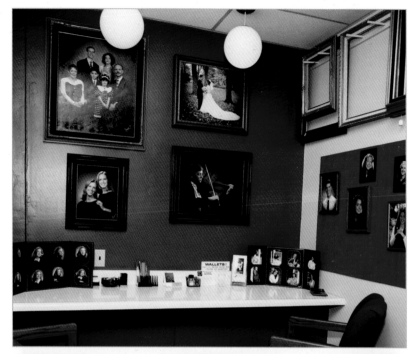

TOP: *Portrait sales area shows only portrait products.* BOTTOM: *Their award wall is a silent testament to their father-son success story.*

shot deal with our commercial clients," the father explained. "We have clients as far back as thirty-five years. They were start-up high tech companies that made it. We still have those clients because we take time to work with them and have them work with us."

In addition to blending portrait and commercial business under one roof, the Micciche duo must blend two generations and two personalities. Tom joined his father in 1987, shortly after graduating from high school. He prefers more contemporary lighting styles while Al likes traditional. Al said Tom has a more lively, energetic personality where he tends to be quiet and meticulous. The result is a combination of Tom's bent toward unique and unconventional images with Al's attention to detail, and technically perfect classic style.

"I like lighting with colorful lights and showing only part of the actual image," Tom said, adding, "I like things that are

*BELOW: Al's signature style, "Optical Array," nets him awards at professional photography competitions on the state, regional and national levels.*

*ABOVE: Following in his father's successful footsteps but with his own look, Tom racks up awards with "Red Hot Blues."*

pretty far off the wall from mainstream 'normal' corporate." Meanwhile, Al goes for traditional. He said, "I will set up the shot so it is technically perfect. I will meticulously space the ten to fifteen products in the set, getting the space exactly correct. I know any mistake we make during the setup will be very noticeable once the photo is on the cover of their brochure." Then he takes equal care to position the lights and the reflector cards.

Compromise is inevitable. Al said, "Sometimes it is not easy working with your father, but then sometimes it is tough working with your son." Tom responded, "His perspective is old-time from working with my grandfather, and mine is a fresh perspective that comes from my age. Of course, neither perspective is right every time." The compromises almost always revolve around technical issues of how to actually light the product. They said they both look for the happy medium to keep both photographers happy.

# Feng Shui and Psychographics

David and Susan Clapp designed their Kingsport, Tennessee studio around the oriental Feng Shui and psychographics decor styles. Located in a professional office building, the Clapps wanted the mood to be professional, but also relaxed and soothing, so they chose the two styles that blend the art of color and placement.

Just as Victorian has its distinct elements, Feng Shui and psychographics styles define specific looks. The objective is to have an open, relaxed and comfortable feeling. Susan explained, "We used soft, curved lines for the furniture as well as for the

*ABOVE: The visual welcome includes grand 8½' doors that open to a gallery entranceway. The soft lines of the furniture and the graceful curve of the wall invite their clients into a welcome room. Classic Feng Shui.*

*ABOVE: The arched doors transition clients from the foyer to the camera room and gallery.*

walls dividing the rooms. The walls are treated with a texture that has the look and feel of soft leather. We chose terra cotta, a peachy, warm, brick color, to enhance the relaxed feeling." You won't find a bathroom in the entranceway or chrome furniture in the reception room.

David pointed out that the furniture in the studio should match the product you are selling clients. "Our furnishings at the gallery are a lot more expensive and upscale than what we have in our home. Our clients do not necessarily have to be upscale people, but they have to desire an upscale product," he said.

The Clapps began photographing weddings out of their home in 1983. They were both newly graduated from college with full-time jobs. They considered photographing weddings

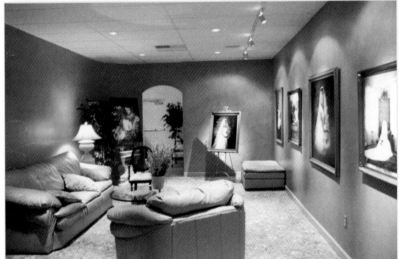

TOP: *The doorless doorway gives privacy to the work area without the harshness of an actual door being visible.* BOTTOM: *The gallery area represents the largest open space and is the most important room in the facility. The furniture is comfortable and inviting. The Clapps use muted colors to enhance the mood and professional lighting to set off the sample wall portraits.*

"fun money" and were happy they did not have to depend on weddings as their only source of income. Susan worked for a large orthodontic practice and David was a chemical engineer. They actually discouraged studio portraits because their only "studio" was their dining room. Susan laughed as she explained, "We had to tie the chandelier back so David could set up the studio lights. It looked like the *Rocky Horror Picture Show*. We did five or six portraits that way, and it was five or six too many!"

After operating out of their home for about twelve years, the house became overrun with albums and negatives and works in progress. It was time to move. They began the search for the ideal location. "We knew we wanted a location that would discourage walk-in traffic. We also wanted it to be convenient for our clients to get to, have plenty of parking and be situated where there was room for expansion," David explained. A professional office building on the outskirts of town met the criteria. In 1996, the Clapps moved into the 1,500 square foot studio. Two and a half years later, the abutting business moved out and the Clapps doubled their studio space to 3,000 square feet.

In spite of all the space they now enjoy, Susan said it is the gallery, which represents about thirty percent of the total square footage, that makes or breaks whether or not clients

select their studio. "It is important to make the design of the reception room compatible with your goals and with the clients you want to attract. The decor has to be at the level to match the products we want to sell and to do that without being intimidating," she explained.

The success of their studio has as much to do with their attitude about their business as it does with the facility itself. David said, "Since both of us had full-time jobs, we could try new things for the business that may or may not work. We were not afraid to fail because we had the safety net of our jobs. Also, because we had a limited amount of time, we did things the way we wanted to do them, and always the way that was the least labor intensive and the most financially profitable."

Soon after they moved into their new studio location, David's employer began to downsize and many of the workers—including David—lost their jobs. The "safety net" became the studio. They were faced with the decision of which direction to go with the business. They decided to dive in and increase their weddings and begin offering portraiture. David said, "It is ironic that for many years I said I would not let photography interfere with my being an engineer only to switch gears and say that I would not allow engineering to interfere with my photography."

Both David and Susan advise current and would-be studio owners to exercise caution and restraint when it comes to expanding their businesses. They said to be careful not to go into debt but to pay for everything as you go. "Take it one step at a time and grow as you need to grow," Susan said with David quickly adding, "Don't get in over your heads too quickly. If you feel pressure to have to make a sale, your clients will sense that. If you are relaxed and comfortable and live below your means, then you will have much better results in the sales room and with your overall business success."

*ABOVE: Practical production includes a 30' long custom counter as the main work area. The shelf contains completed orders as well as works in progress. Some of the frames here are pre-sold to clients and others are available for speculation sales.*

# Four Studios

Patricia and Chris Beltrami bought their first studio in 1974, from Chris's father. That starter studio, a combination retail store and portrait business located on Main Street in Barre, Vermont, gradually evolved to the one hundred percent portraiture studio that it is today. The Barre studio is now one of the four portrait/ wedding studios that the Beltramis operate in Vermont and New Hampshire.

ABOVE: *The Beltrami family photographed by window light in their own studio.*

The decor and style and lighting for all four studios are based on the original location. For example, all the studios use indirect lighting to create a soft, easy mood in the reception rooms. The portraits are individually lit with portrait lights, and that reflected light is basi-

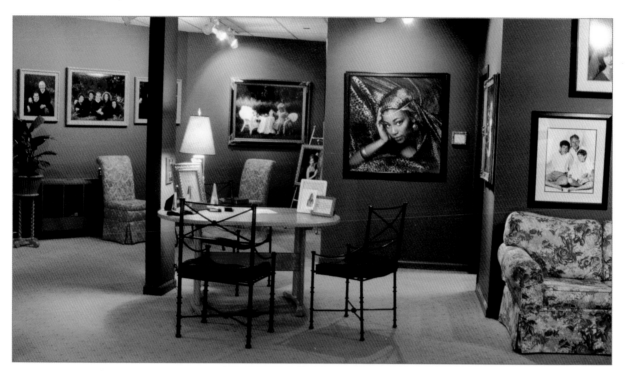

*ABOVE: The Williston studio includes several separate seating areas in an "open" sales room.*

cally the only light in the reception rooms. There are a few table lamps, but they have low wattage bulbs and decorative lamp shades to ensure the lighting remains soft. Patricia said, "This type of lighting is very romantic, and we support that 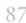 romantic feeling with soft music, candles, and floral bouquets."

The Beltramis put a lot of thought into how the furniture is arranged. Chris explained, "Because of how we have grouped the furniture, there are three totally different areas within the one reception room. Clients can sit and talk in one area while we are helping a client in another. The feeling of the room is friendly and comfortable."

The decorating colors are also basically the same for all four studios. The walls are forest green (except for the Victorian styled studio in Rutland, Vermont where the walls are painted light olive green) and the soft, floral patterns in the furniture pick up hints of rose or dusty gold or dusty blue.

In spite of the strong common denominators, each studio has a bit of its own look and style. Chris said, "At the Barre studio, we want people to say 'Wow!' when they walk in the front door. That theme accents the portraits and the quality and class of what we are all about." The Burlington, Vermont studio is

*Left: The light that creates the north light effect is a Photogenic 650 set at three-quarter power to give a reading of f8 or f11 in the camera room (with film ISO of 160). Right: Removable grill can be used behind the scenes to give a more distinct "window" look.*

88

an igloo-shaped building that has three attached domes. He explained, "We squared off the walls in the entranceway so it has the same feeling as our Barre studio."

Their smallest studio, located in West Lebanon, New Hampshire, is 1,500 square feet. It is situated in a small boutique type mall. The newest studio, located in Rutland, Vermont, is a huge Victorian home. It has 2,400 square feet just for the studio, plus five apartments. "It is huge and it is gorgeous," Patricia said, adding, "There are tall, Victorian-styled windows that go floor to ceiling. It has 2' wide molding around all the ceilings, complete with all the intricate carvings."

Juggling four studios in four cities and two states might sound like an intimidating venture for photographers struggling to keep just one running smoothly. Chris attributes the success to the staff. They have fifteen total staff members including their daughter, Christy, and her husband, Bryan, who run the Burlington studio. Patricia and Chris headquarter at the Barre studio, which is centrally located one hour from all the other studios.

Chris explained that there are only 500,000 people in the entire state of Vermont. Rutland has 17,000 people and is the

TOP, LEFT: *Rutland studio reception room.*
TOP, RIGHT: *Table lamps enhance the soft mood.*
BOTTOM: *Light walls help to set off the floor-to-ceiling Victorian windows.*

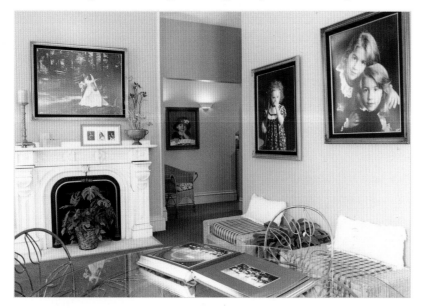

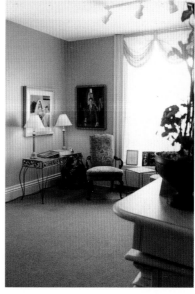

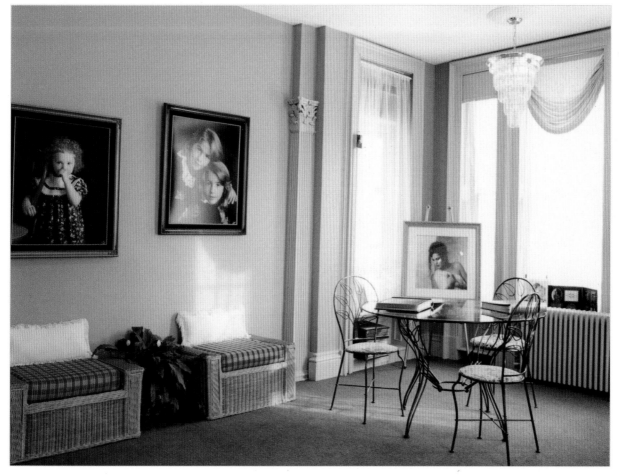

second largest city in the state. Their Barre studio is in a town of only 12,000. "To make a lot of money in photography, particularly when you work in a rural area, you have to have more than one studio," he said. "We established a goal in 1977 to take time off for long periods of time, and the only way to do that was to have several studios and train a staff so we did not have to be there on a daily basis." They work at the Barre studio from 7 a.m. to 1 p.m., Tuesday through Friday, overseeing running the business. They also each photograph about 75 designer-type sessions during the year.

Patricia said when it comes to running multiple studios, you have to have the ability to be flexible with your staff. "You

LEFT: *Tabletop displays create a soft-sell for gift certificates while also showing off awards won at professional photography competitions.*
OPPOSITE, TOP: *The Beltrami "brag wall."*
OPPOSITE, BOTTOM: *Williston gallery room.*

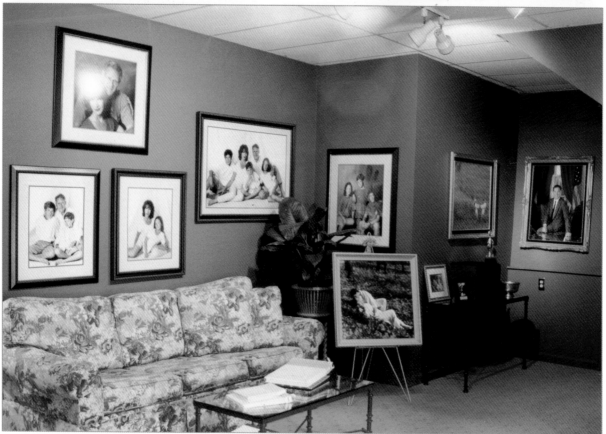

must learn to cut some slack when it comes to your employees. If you expect your staff to be perfect, then your staff will be miserable and you will too."

Chris added, "You have to be able to emotionally and mentally accept that each person has certain gifts and talents and that not everyone is gifted and talented in the same way. As leaders, our job is to uncover those talents in our staff and then guide them to use those talents to the fullest."

*RIGHT: A single light on the other side of the sheer curtains creates the north-light type of lighting. The simple setup requires no fill light, no hair light, and no background light. This north light becomes the fill light when the Beltramis photograph on the right side of the camera room (see full room below). The setup is so popular, they added a similar lighting situation to the other three studios.*
*BELOW: Camera room offers a wide range of backgrounds and settings, but 95% of the sessions are photographed using the left side of the room with the soft north light (see above).*

92

# Rural
# Remote

# Texas Rural Remote

Doug and Barbara Box define their location as "country," but rural remote is much more accurate. The property is carved out of a 110-acre cattle ranch located seven miles outside of Caldwell, Texas, a central Texas town of only 2,500. Located 25 miles from the nearest urban center, it takes an expedition just to reach Doug Box Photography. The majority of their business comes from Bryan and College Station, located thirty minutes away and boasting 100,000 in population plus another 50,000 students attending Texas A&M University.

*The most unusual part of the Box location is that it is located twenty-five miles from civilization. The rural setting brings clients down tree-lined country roads.*

The actual office and gallery are built in a converted barn located near the house. There is a four-acre lake just out of the front door, and the studio is surrounded by thirty acres of hardwood trees.

Doug and Barbara decorated the studio to stay in keeping with the rural setting. "If we did something upscale in the converted barn, it would feel too weird, too unnatural," Doug said. "It is a nice, comfortable space, but not overly formal. You know you are in a converted barn, and we don't try to hide that."

Barbara points out that it is the "hard to get to" issue that adds to their appeal. She

*ABOVE: They use a golf cart to bring clients around the property. Family pets serve as mascots.*
*LEFT: The gallery area uses professional lighting to set off the quality work. The lights literally focus a beam of light on the work, preventing any light from falling on the wall or ceiling around the piece.*

said they can get away with their remote location because of the leniency given to artists. "It is like we are the artists living out in the country, doing our thing," she said with a chuckle.

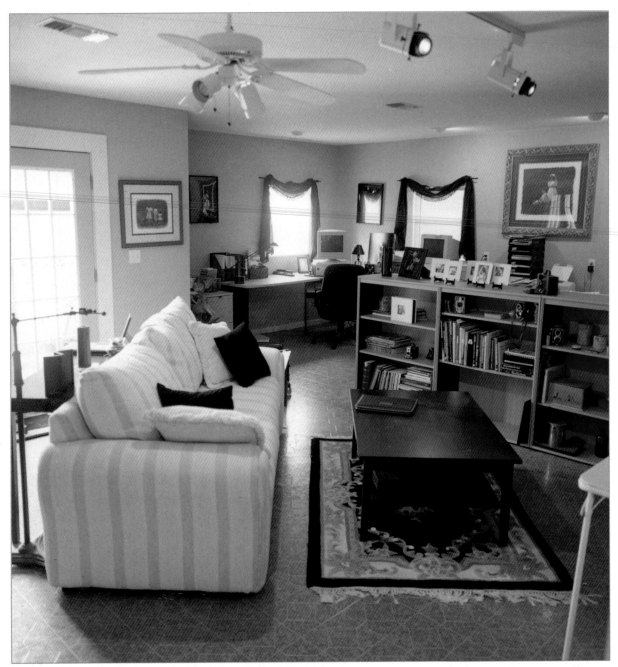

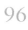

*ABOVE: Simple furnishings transform the former barn into a studio gallery.*

Doug said getting to the studio is half of the fun of working with Doug Box Photography. Clients must travel ten miles down Farm to Market Road 166, turn on the tree-lined County Road 234, make a sharp right when the road turns to gravel, travel another mile across three cattle guards, finally arriving at the big barn in the middle of nowhere. "It is an adventure getting here, but it is worth the effort," Doug said, adding, "The whole setting is peaceful, quiet, serene and

incredibly beautiful." Once clients arrive, they are toted around the property in a four passenger golf cart.

To head off any objections in advance, Doug and Barbara pre-qualify clients before they ever make the long drive to the remote studio location. Doug explained that he will spend thirty to forty minutes on the telephone talking with clients, particularly brides, about their photography goals. He said, "The phone time separates us from others they might call. I do a lot of selling right on the telephone. I let them feel comfortable with who we are and what photography services we offer."

They also offer a detailed planning guide, complete with directions and prices, for wedding and portrait clients. The ten-page booklet includes eight to ten wallet photographs that are custom selected to target the taste and style of the client. For example, the wedding booklet shows samples from the couple's ceremony and reception locations and includes black and white samples if they have shown an interest in that medium. They also use several satellite studio locations. These are located in related businesses like florists and wedding consultant offices, and Doug or Barbara will happily meet a client at one of these centrally-located satellite locations.

*BELOW: The coffee table book clients view serves as a brag book and a photography showcase. Each page features a "well done" note from a client, paired with a photograph from the wedding or portrait session to identify the happy client. There are no other albums left out, so clients always turn the pages of this beautiful brag book.*

Doug said comments from two clients in one day summed up the pros and cons of their remote studio location. One client said, "If I had known you were in Caldwell before I made the telephone call, I never would have called in the first place." The other said, "You must be good

to be able to live out here and do what you do." Both clients booked.

*ABOVE: The Box team photographs about thirty weddings per year. Doug offers color coverage and emphasizes natural light. Barbara works in a photojournalist style in black & white.*

To help clients with the out-of-the-way location, Doug and Barbara go out of their way to offer extra service. Brides select the length of coverage and the amount of photographs from a variety of packages. The Boxes deliver the bride's selection as a completed album about five weeks after the wedding. Couples do not have to make that extra trip back to the remote studio. Instead, Doug or Barbara will personally deliver the album to the couple. They offer a similar service for completed pieces for their portrait clientele. "There is nothing we won't do for our clients. We want to make it as easy as possible for them to work with us," explained Barbara.

RON SIMONS

# Studio
# in the Woods

Simons' Photographic is nestled in the heart of the deep woods of rural Maine. Ron Simons said, "You always hear 'location, location, location,' but I went against conventional wisdom and it worked."

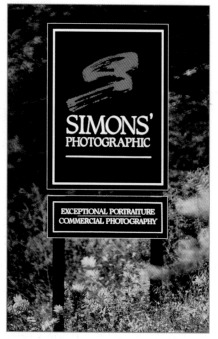

*ABOVE: The sign greets clients at the driveway to the studio entrance.*

He built his dream studio on a rural road two miles away from the small town of Readfield, Maine (population 2,000) and fifteen miles from the state capital of Augusta. It takes several "Simons' Photographic" road signs, strategically placed on the highway, to enable clients to find the beautiful studio he custom designed to attach to his home. Ron said visiting photographers often quip about his studio being located in the middle of nowhere, but he said the rural drive into the country helps his clients to arrive relaxed.

"The lifestyle in central Maine is casual and relaxed, not like the hurried life in a big city," Ron explained. "That is the way I am and one of the many reasons that I moved to Maine in the first place. I want my studio to reflect that same relaxed feeling. I want my customers to feel like they are going to

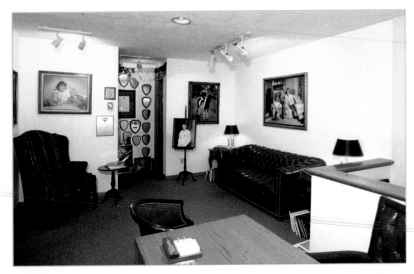

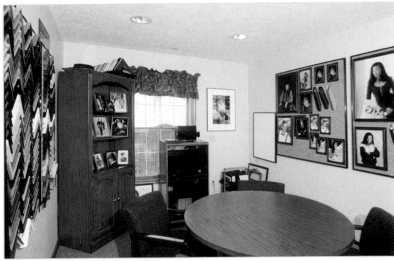

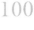
TOP: *From the front door, clients walk up a short flight of stairs to the reception room. The production room is straight ahead and a small sales/projection room is off to the left.* BOTTOM: *Entering the sales room, the high school senior wall on the right shows the entire selection of the popular senior packages he offers. Selling custom frames (left wall) allows clients to choose their favorites and eliminates storing ready-made frames.*

be treated in a friendly and professional manner. I also wanted the studio to convey the message that I am proud of what I create and that the work is worth the price I charge," he added.

In 1984, he designed the studio to accommodate the two separate market segments he serves, fifty percent portrait and fifty percent commercial. The 24'x44' two-story addition is attached to his home and includes a reception area, sales room and office space on the upper level. The lower level has a 20'x24' portrait camera room and a 16'x20' commercial camera room. Both camera rooms have 12' high ceilings.

Ron said the most important aspect of building a home-based studio is to check with your local town ordinances to make sure you comply with the rules. "Surprises are only fun for birthdays and Christmas," he said. To consider Simons' Photographic a home occupation, his zoning board allowed him 2,500 square feet of total business space. To enhance the professional image of his studio and

to provide privacy for his family, the studio design includes a separate driveway with separate parking and a separate entrance.

"The door in between the studio and the home reminds me that there is a business life and a personal life. That separation allows me to go back and forth between my two worlds," Ron said.

Ten acres of woodland surround the home studio, making "on location" as convenient as his own backyard. The property includes old stone walls that have been there for 200 years, a variety of hardwood, evergreen and birch trees, and grassy

*TOP: The portrait camera room includes a low key side. BOTTOM: The high key side includes an actual window for natural light portraits.*

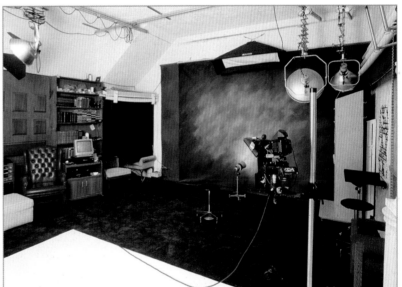

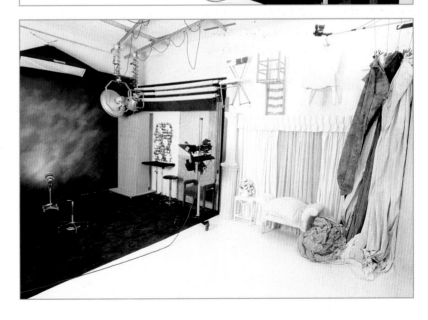

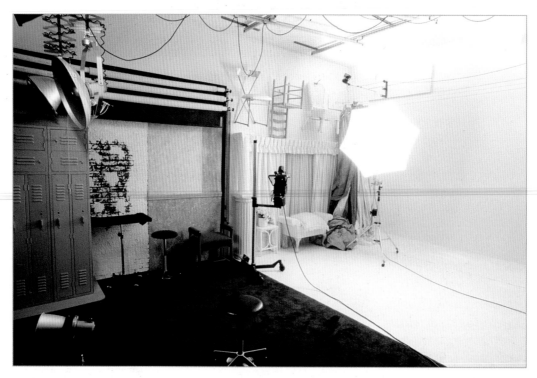

TOP: *Ron uses the sides of his portrait studio for smaller sets, like the gym lockers, that appeal to high school seniors.*
BOTTOM: *His commercial camera room has its own set of lights, backgrounds and props.*

areas. To add variety for his high school senior portraits, Ron dug a small pond and built a shed.

Ron said no matter how well you plan your space before you build, you can always use "just a little more" once the building is up and running. He said, on the one hand, space is very expensive to build, but lack of it down the road can be very frustrating. "Think through what you think you need, and then add that little bit more," he advised.

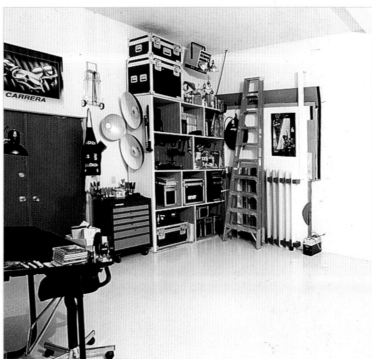

*ABOVE: While photographing a manufactured home for a brochure, Ron had to back into a closet with his wide angle lens on his Sinar 4x5 view camera. An associate took a quick shot of him to prove to the world how hard he works for his money. RIGHT: Ron built a high shelf in the commercial room to give added storage.*

# International Flavor

# Quiet Canadian Elegance

Louise and Joseph Simone photograph wealthy clients in Montreal, Canada. The quiet couple pursues classic portraiture with a lean toward elegant. They do most of their 150 sessions a year working together, and they create the majority of those images in the studio.

"We have a vision to create a portrait that is timeless and to capture the soul of the persons we photograph," Louise said.

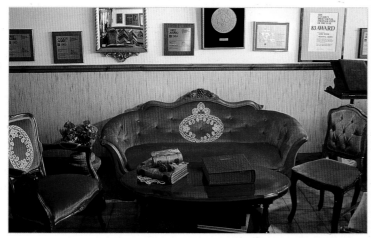

*ABOVE: The Simones use antiques to achieve classic elegance.*

They spend twenty minutes to two hours with clients at a planning session in the studio. Then, if clients prefer, they will schedule another appointment to meet for coffee at the client's home. Joseph said the home appointment allows them to see clients in their natural environment, revealing their natures and characters. During the planning sessions, the two master photographers watch the clients, looking for body language and facial expressions that they may later capture on film.

Theirs hasn't always been such a class act. They began their photographic careers in the mid-70s photographing students. They bought their first studio in 1975. Six years later, in 1981, they went through a life-changing personal experience that made them rethink their business goals. Louise explained, "We have this one life. We do not want to spend our life to just burn it. If we cannot love people, then it is impossible to photograph them at their best. To love people, we must accept them unconditionally. We must also slow down and take time to get to know them."

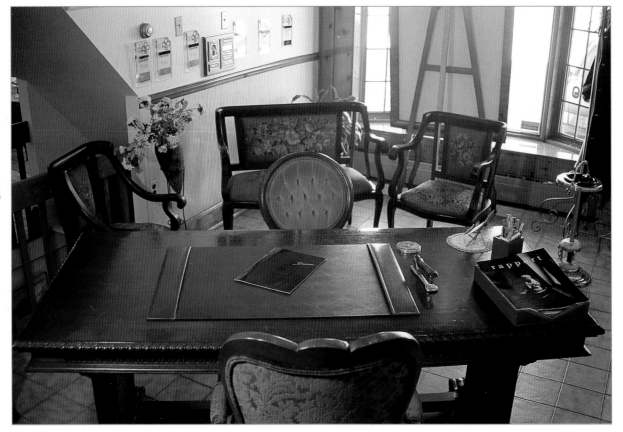

*ABOVE: Order desk.*

Joseph said, "The people in front of us are a mirror of ourselves and a mirror of their souls. If we project our warmth for them, then we can capture their spirit. We pull to us the same kind of people that we are. You can see the evolution of yourself through your portraits."

They redesigned their printed materials and created a new studio to match their new business vision. "In the beginning, we gradually made changes to our photography and to the stu-

dio," Louise explained, adding, "When we felt ready and when we felt our clients were ready, we did the big studio renovation. We closed our door to the old way and now follow our vision to create elegant art pieces that capture the spirits and souls of our clients."

The Simones chose the classic antique style because of its elegant and timeless appeal. "If you decorate with modern furniture then you must change it every four or five years. Antique pieces never go out of style," Louise said. Their decor includes fresh flowers and wall portraits that are all 30"x40".

"We chose a look that creates a warm atmosphere. The furniture is curved and comfortable. We used lush velvet fabrics for richness, and lace on the backs of the chairs for romance and elegance," she added.

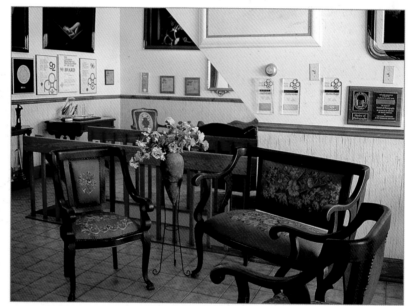

They attribute their success to keeping their focus on the vision they established for their studio when they made the renovations in 1981. "When you choose a vision and stay with the path, your business has focus. Customers gain confidence because they feel you know what you are doing." Joseph said, adding, "On one hand, clients let us have a free hand, but on the other hand we must listen to what they want. Otherwise, it will be a portrait for us and not for them."

*ABOVE: Studio overview.*

# Danish Design and Decor

Ib Larsen and Kitty Reedorf believe the design and decor of their Odense, Denmark studio should inspire their clients. "If our studio shows the ideal environment for displaying fine portraiture, we will inspire our clients to treat their portraits as fine art," Ib explained. Kitty added, "If you want a clientele willing to spend a lot of money for your portraits, then you have to style your studio as exclusively as you believe your clients' homes are styled. Show only quality in your portraits, in your framing and in your decor. Oh, and do not serve coffee in plastic cups."

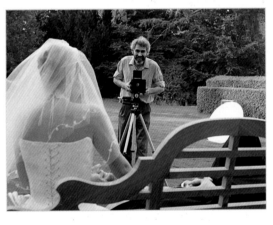

ABOVE: *Ib, photographing a bride on the studio grounds.*

They first opened Portrait Studiet in 1988 in an area with a modern art museum and a museum for photography, Brandts Klaedefabrik, that had been rebuilt the previous year from an abandoned factory. "Everybody wanted to see this new

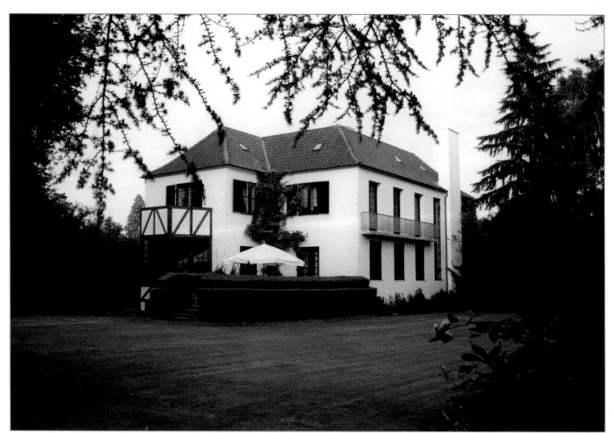

museum and a lot of people came to see Brandts Klaedefabrik and our studio the first couple of years," Ib said. Then the novelty wore off and only day tourists visited the museum. Odense is the birthplace of Hans Christian Anderson and an important tourist destination with a population of 200,000.

*ABOVE: Located in an upscale area, the studio boasts parklike grounds with easy access for environmental portraits.*

In response, the couple relocated their studio to the heart of the city's shopping district. The shop and gallery were on the ground floor and the studio was on the first. In 1999, they moved the studio two miles outside of the city center to an exclusive address with a large home and a parklike garden. "Our goal is to look exclusive, to attract the best clientele and to avoid using a lot of time with people who are not willing to pay our prices," Ib explained.

They decorated the reception area with fine mahogany furniture and hung large portraits on the walls. The hallway has a vaulted ceiling with an open fireplace and a staircase that leads to a balcony gallery and the waiting room. "The hall is very special. Almost all our customers comment on it," Kitty said,

adding, "They are impressed by the environment both inside and out."

Their photographic studio includes custom-painted backdrops on the walls that give a panel effect (see photo, next page). They also photograph in the gallery area, hallway and staircase using either natural light or strobes. "Most of the studios in Denmark photograph only in their studios. We have the studio to provide this service to our clients too. We are gradually educating our clients to the ideas of other countries where most of the photography is done outdoors. More and more we see our clients showing a growing interest in portraits made outside. Our new studio, with its garden location, makes mixing outdoor portraits and studio portraits easy for us and easy for our clients," Ib said.

*BELOW: The staircase leads to a balcony gallery area and the studio waiting room.*

Both Ib and Kitty are big believers in keeping current on all areas of their business. They attend photographic conventions and travel internationally to tour successful studios. The continual input of fresh ideas inspires them photographically and also brings the newest and best business, marketing and decor ideas to their clients.

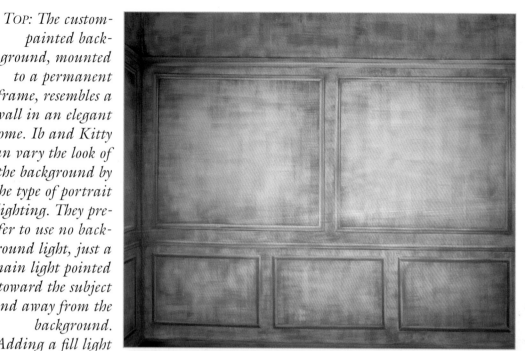

TOP: *The custom-painted background, mounted to a permanent frame, resembles a wall in an elegant home. Ib and Kitty can vary the look of the background by the type of portrait lighting. They prefer to use no background light, just a main light pointed toward the subject and away from the background. Adding a fill light to the subject gives the fall-off needed to create what Ib calls "the perfect look."*

BOTTOM: *This whimsical image of wedded bliss features another custom-painted backdrop.*

# Converted Leather Factory

After several years of operating their portrait and wedding studio from a mall location while living in a residential section of Christchurch, New Zealand, Margaritha and Peter Straw wanted to combine their living and working spaces under one roof. They looked for a home that could also be used for a business, but they ran into too many zoning issues. "There were so many rules about staff and hours and percentage of square footage that could be allowed for a business in your home that it made it difficult to do a home studio legally," Peter explained.

*ABOVE: It takes optimism and hard work to transform a former leather factory into an upscale portrait studio.*

The husband-wife photography team decided to do the next best thing and look for an office space for Beverly Studios

*RIGHT: Before.*
*BELOW: After.*

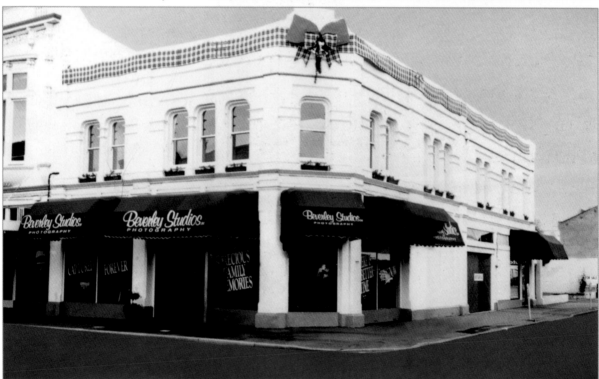

Ltd. where they could legally live. They found an empty ware-house in the heart of the city that had once been used as a leather factory. The 2,500 square feet on the street level pro-vided ample studio space, and the 2,500 above it allowed for a gracious home. In choosing the central city location, they made sure it passed the "easy parking" test. Margaritha said, "We photograph lots of mums with small children and we did not want these mums traipsing all over looking for parking. We wanted plenty of parking within a short radius of the studio."

*TOP: The waiting room is just inside the front door. The alcove to the left leads to the production area.*
*BOTTOM: Entry door to the left. Hallway on the right leads to the camera and production rooms. The spiral staircase leads to the private residence on the second floor.*

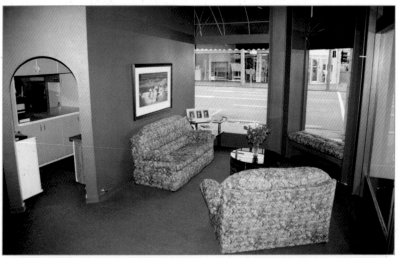

114

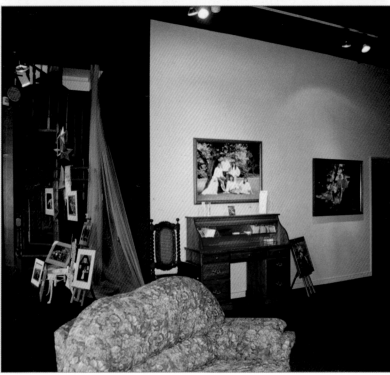

She explained that covering up the walls was the biggest challenge. "They tanned and sprayed leathers with chemicals in the factory. The walls were so stained that we could not hide the damage. We had to build new walls within the walls," she said.

Peter said they designed the interior of the studio portion based upon their previous sixteen years as studio owners. While the warehouse still stood empty, they physically walked through the process of how they greet clients and how they walk them to the dressing room and camera room. They also walked through a sales session. Then they used chalk to mark the floor where the walls should go for the various rooms, closets and bathrooms. He said, "We asked ourselves, 'How does the presentation go? How does a photography session go? How can we get people from place to place the easiest?' We wanted a smooth flow from start to finish so it would be easy for our clients and easy for ourselves."

They used the same experience and the same careful consideration when they selected the colors to paint the interior walls. "We looked at the portraits we take to see which color wall would best set off the portrait styles. Our work is created either at the beach, at the park, or of babies and mums in the studio against a white background," Margaritha said. They chose deep green walls to display the park portraits, and a mauve pink to display the studio/beach portraits.

"After Marg picked out the color combination for the walls, the professional painter told us we could never put those two colors together in one room," Peter said, adding, "But we went ahead and did it anyway. Customers comment all the time on how nice the two colors look together."

Their furniture follows a classical style. They chose the style for its comfort but also for its universal appeal to their clients and for its timeless quality. Peter explained,

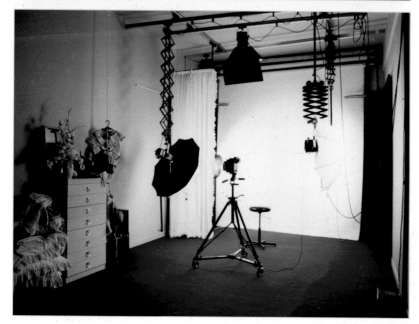

TOP: *The Straws use the hallway as a gallery to showcase samples of their work.* BOTTOM: *Camera room.*

"When you follow an ultramodern fashion, you must plan to change your decor every few years. Traditional styles are the ones that tend to go the distance. They also tend to be the ones that are most comfortable for your clients to relax in."

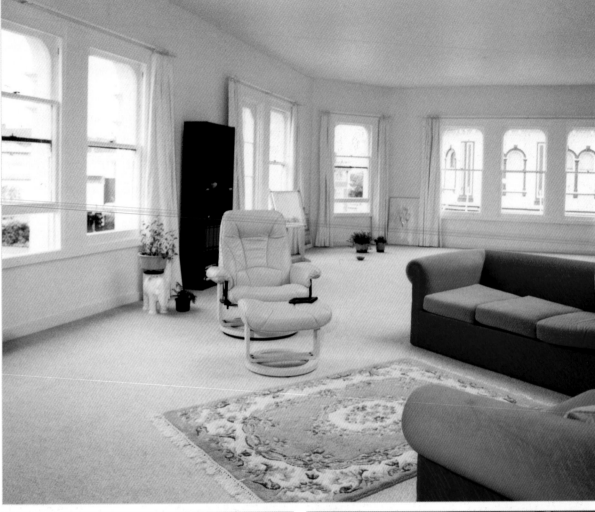

TOP: *The spacious upstairs lounge (living room) in the Straw home overlooks the streets below.*
BOTTOM, LEFT AND RIGHT: *Peter uses a computer and a video projection unit in his sales room to project client images on a viewing screen.*

# Small Space Success

Hugh Jacob relies upon his excellent artistry rather than a glitzy studio, operating Personal Reflections Photographic Art from existing space in his home. Hugh's home is located in Brampton, Ontario, Canada, a bedroom community of 200,000 located thirty minutes from the fifteen million people in Toronto.

He said he chose to use a portion of his multilevel house instead of a commercial building because the home environment helps to break the ice and make people more comfortable and more relaxed. Hugh runs a very low key business, working individually with one client at a time. He does about 150 sittings a year, and his subjects are families, children and couples. He started his first home-based studio in 1981 and has been at this location since 1991.

A popular speaker at photography conferences across the U.S. and in Canada, Hugh said photographers are always

*ABOVE: Hugh calls his front entry his "icebreaking room." He does planning consultations and initial interviews here.*

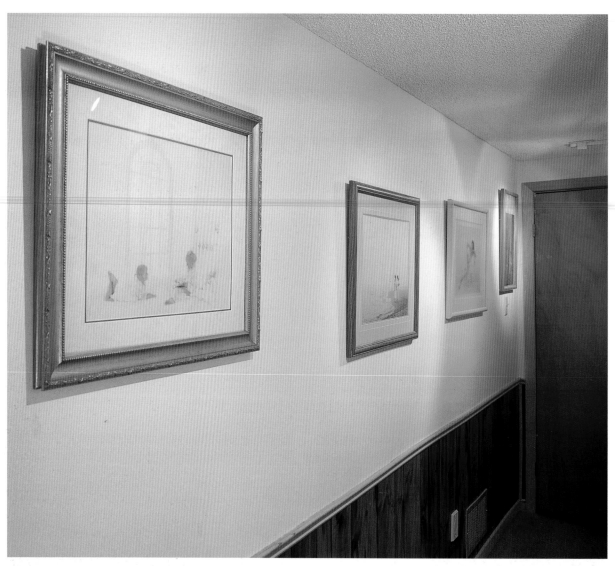

ABOVE: *The downstairs hall-way is the only place Hugh displays more than one portrait on the same wall. All other areas have only one portrait per wall.*

amazed to discover how small his studio is. "Photographers don't believe how much you can do in a relatively small area," he said, adding, "Whether or not you have a large studio space or a small one is often an issue of 'mind over matter.'" He admits that a photographer can never have enough space, but when working with limited space you can stretch that space by carefully planning and using it wisely.

His basic space is 14'x36' with a 9' wide L-shaped section for storage. He uses the front room in his multilevel home as an icebreaker. Then he takes clients down six steps to the gallery area where matted and framed portraits show the variety and style of his portraiture. Hugh likes to appeal to all the senses, including the sense of smell. He groups his client

appointments on two or three days of the week and then schedules his bread baking for those same days. "There is nothing like the smell of fresh baked bread," he said. The aroma adds a homey feeling to the setting and also brings a touch of the personal side of Hugh to the business appointment.

Successful studio decor means more than a nicely appointed room. To Hugh, it means cleanliness. "Clean is very important. I do a lot of vacuuming so the carpets always have that

119

*BELOW: Matted and framed texture screened prints in black and white and color, two of Hugh's signature looks.*

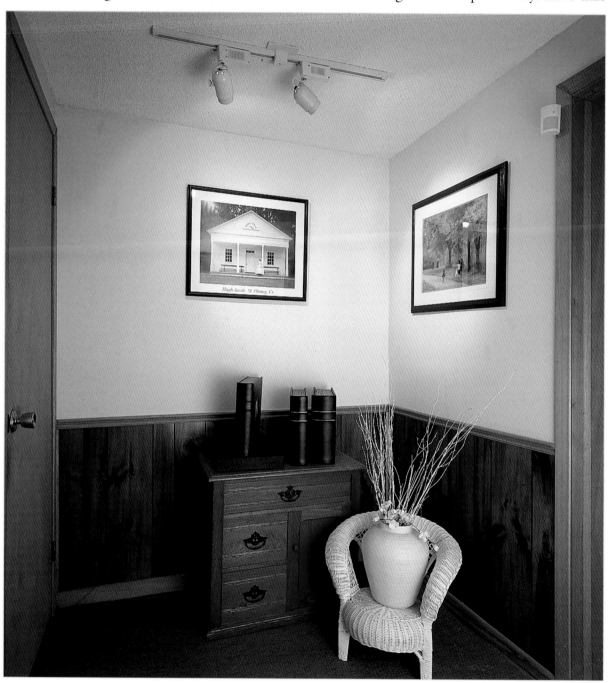

freshly cleaned look. When you go to the extra effort to keep your studio sparkling clean, clients notice," he said.

Since he is not at a mainstream location, Hugh sets aside one day a week to do marketing. He calls prior clients and asks if he can stop by for a short visit to say hello and see how they are doing. He said he also lets them know that he would like to show samples of his new portrait styles. He explained, "My work is always evolving and growing, and I want to show my clients these new looks."

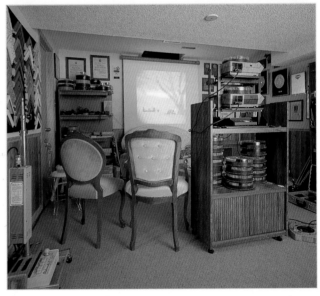

*ABOVE: Although most of Hugh's work is done on location, he does have a small camera room. RIGHT, TOP AND BOTTOM: Hugh must make every inch count in his projection room. He projects slide proofs on the wall for clients to make their selections. One wall holds a selection of frame corners and another wall shows off his many awards from professional print competitions.*

# Index

### Storytelling Wedding Photography

*Barbara Box*

Barbara and her husband shoot as a team at weddings. Here, she shows you how to create outstanding candids (which are her specialty), and combine them with formal portraits (her husband's specialty) to create a unique wedding album. $29.95 list, 8½x11, 128p, 60 b&w photos, order no. 1667.

### Outdoor and Location Portrait Photography

*Jeff Smith*

Learn how to work with natural light, select locations, and make clients look their best. Step-by-step discussions and helpful illustrations teach you the techniques you need to shoot outdoor portraits like a pro! $29.95 list, 8½x11, 128p, 60+ b&w and color photos, index, order no. 1632.

### Professional Secrets of Natural Light Portrait Photography

*Douglas Allen Box*

Learn to utilize natural light to create inexpensive and hassel-free portraiture. Beautifully illustrated with detailed instructions on equipment, setting selection and posing. $29.95 list, 8½x11, 128p, 80 full color photos, order no. 1706.

### Freelance Photographer's Handbook

*Cliff & Nancy Hollenbeck*

Whether you want to be a freelance photographer or are looking for tips to improve your current freelance business, this volume is packed with ideas for creating and maintaining a successful freelance business. $29.95 list, 8½x11, 107p, 100 b&w and color photos, index, glossary, order no. 1633.

## ■ ALSO AVAILABLE

### Wedding Photographer's Handbook

*Robert and Sheila Hurth*

A complete step-by-step guide to succeeding in the world of wedding photography. Packed with shooting tips, equipment lists, must-get photo lists, business strategies, and much more! $24.95 list, 8½x11, 176p, index, 100 b&w and color photos, diagrams, order no. 1485.

### Wedding Photography:
#### Creative Techniques for Lighting and Posing, *2nd Edition*

*Rick Ferro*

Creative techniques for lighting and posing wedding portraits that will set your work apart from the competition. Covers every phase of wedding photography. $29.95 list, 8½x11, 128p, full color photos, index, order no. 1649.

### Lighting for People Photography, *2nd Edition*

*Stephen Crain*

The up-to-date guide to lighting. Includes: set-ups, equipment information, strobe and natural lighting, and much more! Features diagrams, illustrations, and exercises for practicing the techniques discussed in each chapter. $29.95 list, 8½x11, 120p, 80 b&w and color photos, glossary, index, order no. 1296.

### Professional Secrets of Advertising Photography

*Paul Markow*

No-nonsense information for those interested in the business of advertising photography. Includes: how to catch the attention of art directors, make the best bid, and produce the high-quality images your clients demand. $29.95 list, 8½x11, 128p, 80 photos, index, order no. 1638.

### Big Bucks Selling Your Photography, *2nd Edition*

*Cliff Hollenbeck*

A completly updated photo business package. Includes starting up, getting pricing, creating successful portfolios and using the internet as a tool! Features setting financial, marketing and creative goals. Organize your business planning, bookkeeping, and taxes. $17.95 list, 8½, 128p, 30 photos, b&w, order no. 1177.

### Lighting Techniques for Photographers

*Norman Kerr*

This book teaches you to predict the effects of light in the final image. It covers the interplay of light qualities, as well as color compensation and manipulation of light and shadow. $29.95 list, 8½x11, 120p, 150+ color and b&w photos, index, order no. 1564.

## Infrared Photography Handbook

*Laurie White*

Covers black and white infrared photography: focus, lenses, film loading, film speed rating, batch testing, paper stocks, and filters. Black & white photos illustrate how IR film reacts. $29.95 list, 8½x11, 104p, 50 b&w photos, charts & diagrams, order no. 1419.

## How to Shoot and Sell Sports Photography

*David Arndt*

A step-by-step guide for amateur photographers, photojournalism students and journalists seeking to develop the skills and knowledge necessary for success in the demanding field of sports photography. $29.95 list, 8½x11, 120p, 111 photos, index, order no. 1631.

## How to Operate a Successful Photo Portrait Studio

*John Giolas*

Combines photographic techniques with practical business information to create a complete guide book for anyone interested in developing a portrait photography business (or improving an existing business). $29.95 list, 8½x11, 120p, 120 photos, index, order no. 1579.

## Fashion Model Photography

*Billy Pegram*

For the photographer interested in shooting commercial model assignments, or working with models to create portfolios. Includes techniques for dramatic composition, posing, selection of clothing, and more! $29.95 list, 8½x11, 120p, 58 photos, index, order no. 1640.

## Computer Photography Handbook

*Rob Sheppard*

Learn to make the most of your photographs using computer technology! From creating images with digital cameras, to scanning prints and negatives, to manipulating images, you'll learn all the basics of digital imaging. $29.95 list, 8½x11, 128p, 150+ photos, index, order no. 1560.

## Achieving the Ultimate Image

*Ernst Wildi*

Ernst Wildi teaches the techniques required to take world class, technically flawless photos. Features: exposure, metering, the Zone System, composition, evaluating an image, and more! $29.95 list, 8½x11, 128p, 120 b&w and color photos, index, order no. 1628.

## Profitable Portrait Photography

*Roger Berg*

A step-by-step guide to making money in portrait photography. Combines information on portrait photography with detailed business plans to form a comprehensive manual for starting or improving your business. $29.95 list, 8½x11, 104p, 100 photos, index, order no. 1570

## Handcoloring Photographs Step-by-Step

*Sandra Laird & Carey Chambers*

Learn to handcolor photographs step-by-step with the new standard in handcoloring reference books. Covers a variety of coloring media and techniques with plenty of colorful photographic examples. $29.95 list, 8½x11, 112p, 100+ color and b&w photos, order no. 1543.

## Special Effects Photography Handbook

*Elinor Stecker-Orel*

Create magic on film with special effects! Little or no additional equipment required, use things you probably have around the house. Step-by-step instructions guide you through each effect. $29.95 list, 8½x11, 112p, 80+ color and b&w photos, index, glossary, order no. 1614.

## McBroom's Camera Bluebook, 6th Edition

*Mike McBroom*

Comprehensive and fully illustrated, with price information on: 35mm, digital, APS, underwater, medium & large format cameras, exposure meters, strobes and accessories. Pricing info based on equipment condition. A must for any camera buyer, dealer, or collector! $29.95 list, 8½x11, 336p, 275+ photos, order no. 1553.

## Fine Art Portrait Photography

*Oscar Lozoya*

The author examines a selection of his best photographs, and provides detailed technical information about how he created each. Lighting diagrams accompany each photograph. $29.95 list, 8½x11, 128p, 58 photos, index, order no. 1630.

## Black & White Landscape Photography

*John Collett and David Collett*

Master the art of b&w landscape photography. Includes: selecting equipment (cameras, lenses, filters, etc.) for landscape photography, shooting in the field, using the Zone System, and printing your images for professional results. $29.95 list, 8½x11, 128p, 80 b&w photos, order no. 1654.

## The Art of Infrared Photography, *4th Edition*

*Joe Paduano*

A practical guide to the art of infrared photography. Tells what to expect and how to control results. Includes: anticipating effects, color infrared, digital infrared, using filters, focusing, developing, printing, handcoloring, toning, and more! $29.95 list, 8½x11, 112p, 70 photos, order no. 1052

## Studio Portrait Photography of Children and Babies

*Marilyn Sholin*

Learn to work with the youngest portrait clients to create images that will be treasured for years to come. Includes tips for working with kids at every developmental stage, from infant to preschooler. Features: lighting, posing and much more! $29.95 list, 8½x11, 128p, 60 photos, order no. 1657.

## The Art of Portrait Photography

*Michael Grecco*

Michael Grecco reveals the secrets behind his dramatic portraits which have appeared in magazines such as *Rolling Stone* and *Entertainment Weekly*. Includes: lighting, posing, creative development, and more! $29.95 list, 8½x11, 128p, 60 photos, order no. 1651.

## Photographer's Guide to Shooting Model & Actor Portfolios

*CJ Elfont, Edna Elfont and Alan Lowy*

Learn to create outstanding images for actors and models looking for work in fashion, theater, television, or the big screen. Includes the business, photographic and professional information you need to succeed! $29.95 list, 8½x11, 128p, 100 photos, order no. 1659.

## Essential Skills for Nature Photography

*Cub Kahn*

Learn all the skills you need to capture landscapes, animals, flowers and the entire natural world on film. Includes: selecting equipment, choosing locations, evaluating compositions, filters, and much more! $29.95 list, 8½x11, 128p, 60 photos, order no. 1652.

## Photo Retouching with Adobe® Photoshop®

*Gwen Lute*

Designed for photographers, this manual teaches every phase of the process, from scanning to final output. Learn to restore damaged photos, correct imperfections, create realistic composite images and correct for dazzling color. $29.95 list, 8½x11, 120p, 60+ photos, order no. 1660.

## Photographer's Guide to Polaroid Transfer

*Christopher Grey*

Step-by-step instructions make it easy to master Polaroid transfer and emulsion lift-off techniques and add new dimensions to your photographic imaging. Fully illustrated every step of the way to ensure good results the very first time! $29.95 list, 8½x11, 128p, 50 photos, order no. 1653.

## Creative Lighting Techniques for Studio Photographers

*Dave Montizambert*

Master studio lighting and gain complete creative control over your images. Whether you are shooting portraits, cars, table-top or any other subject, Dave Montizambert teaches you the skills you need to confidently create with light. $29.95 list, 8½x11, 120p, 80+ photos, order no. 1666.

## Fine Art Children's Photography

*Doris Carol Doyle and Ian Doyle*

Learn to create fine art portraits of children in black & white. Included is information on: posing, lighting for studio portraits, shooting on location, clothing selection, working with kids and parents, and much more! $29.95 list, 8½x11, 128p, 60 photos, order no. 1668.

## Infrared Portrait Photography

*Richard Beitzel*

Discover the unique beauty of infrared portraits, and learn to create them yourself. Included is information on: shooting with infrared, selecting subjects and settings, filtration, lighting, and much more! $29.95 list, 8½x11, 128p, 60 b&w photos, order no. 1669.

## Composition Techniques from a Master Photographer

*Ernst Wildi*

In photography, composition can make the difference between dull and dazzling. Master photographer Ernst Wildi teaches you his techniques for evaluating subjects and composing powerful images in this beautiful full color book. $29.95 list, 8½x11, 128p, 100+ full color photos order no. 1685.

## Innovative Techniques for Wedding Photography

*David Neil Arndt*

Spice up your wedding photography (and attract new clients) with dozens of creative techniques from top-notch professional wedding photographers! $29.95 list, 8½x11, 120p, 60 photos, order no. 1684.

## Art and Science of Butterfly Photography

*William Folsom*

Learn to understand and predict butterfly behavior (including feeding, mating and migrational patterns), when to photograph them and even how to lure butterflies. Then discover the photographic techniques for capturing breath-taking images of these colorful creatures. $29.95 list, 8½x11, 120p, 100 photos, order no. 1680.

## Infrared Wedding Photography

*Patrick Rice, Barbara Rice & Travis HIll*

Step-by-step techniques for adding the dreamy look of black & white infrared to your wedding portraiture. Capture the fantasy of the wedding with unique ethereal portraits your clients will love! $29.95 list, 8½x11, 128p, 60 images, order no. 1681.

## Dramatic Black & White Photography:

### Shooting and Darkroom Techniques

*J.D. Hayward*

Create dramatic fine-art images and portraits with the master b&w techniques in this book. From outstanding lighting techniques to top-notch, creative darkroom work, this book takes b&w to the next level! $29.95 list, 8½x11, 128p, order no. 1687.

## Photographing Your Artwork

*Russell Hart*

A step-by-step guide for taking high-quality slides of artwork for submission to galleries, magazines, grant committees, etc. Learn the best photographic techniques to make your artwork (be it 2D or 3D) look its very best! $29.95 list, 8½x11, 128p, 80 b&w photos, order no. 1688.

## Posing and Lighting Techniques for Studio Photographers

*J.J. Allen*

Master the skills you need to create beautiful lighting for portraits of any subject. Posing techniques for flattering, classic images help turn every portrait into a work of art. $29.95 list, 8½x11, 120p, 125 fullcolor photos, order no. 1701.

## Studio Portrait Photography in Black & White

*David Derex*

From concept to presentation, you'll learn how to select clothes, create beautiful lighting, prop and pose top-quality black & white portraits in the studio. $29.95 list, 8½x11, 128p, 70 photos, order no. 1689.

## Watercolor Portrait Photography: The Art of Manipulating Polaroid SX-70 Images

*Helen T. Boursier*

Create one-of-a-kind images with this surprisingly easy artistic technique. $29.95 list, 8½x11, 120p, 200+ color photos, order no. 1698.

## Techniques for Black & White Photography: Creativity and Design

*Roger Fremier*

Harness your creativity and improve your photographic design with these techniques and exercises. From shooting to editing your results, it's a complete course for photographers who want to be more creative. $19.95 list, 8½x11, 112p, 30 photos, order no. 1699.

## Corrective Lighting and Posing Techniques for Portrait Photographers

*Jeff Smith*

Learn to make every client look his or her best by using lighting and posing to conceal real or imagined flaws – from baldness, to acne, to figure flaws. $29.95 list, 8½x11, 120p, full color, 150 photos, order no. 1711.

## Basic Digital Photography

*Ron Eggers*

Step-by-step text and clear explanations teach you how to select and use all types of digital cameras. Learn all the basics with no-nonsense, easy to follow text designed to bring even true novices up to speed quickly and easily. $17.95 list, 8½x11, 80p, 40 b&w photos, order no. 1701.

## Make-Up Techniques for Photography

*Cliff Hollenbeck*

Step-by-step text paired with photographic illustrations teach you the art of photographic make-up. Learn to make every portrait subject look his or her best with great styling techniques for black & white or color photography. $29.95 list, 8½x11, 120p, 80 full color photos, order no. 1704

## Portrait Photographer's Handbook

*Bill Hurter*

Bill Hurter has compiled a step-by-step guide to portraiture that easily leads the reader through all phases of portrait photography. This book will be an asset to experienced photographers and beginners alike. $29.95 list, 8½x11, 128p, full color, 60 photos, order no. 1708.

## Basic Scanning Guide For Photographers and Creative Types

*Rob Sheppard*

This how-to manual is an easy-to-read, hands on workbook that offers practical knowledge of scanning. It also includes excellent sections on the mechanics of scanning and scanner selection. $17.95 list, 8½x11, 96p, 80 photos, order no. 1708.